REX CONWAY'S
SOUTHERN
STEAM JOURNEY

VOLUME TWO

The History Press

Other books by Rex Conway:

Rex Conway's Steam Album

Rex Conway's Western Steam Journey

Rex Conway's Midland Steam Journey Volume One

Rex Conway's Midland Steam Journey Volume Two

Rex Conway's GWR Album

Rex Conway's Eastern Steam Journey Volume One

Rex Conway's Eastern Steam Journey Volume Two

Rex Conway's Southern Steam Journey Volume One

First published 2011

The History Press
The Mill, Brimscombe Port
Stroud, Gloucestershire, GL5 2QG
www.thehistorypress.co.uk

British Library Cataloguing in Publication Data.
A catalogue record for this book is available from the British Library.

ISBN 978 0 7524 5758 1
Typesetting and origination by The History Press
Printed in Malta

Contents

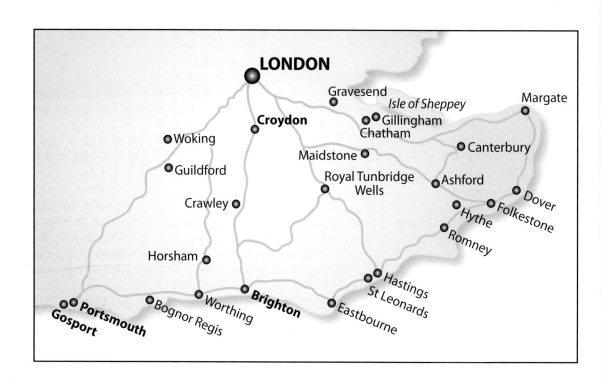

Introduction

Southern Journey Volume Two is my last journey of the 'Big Four' as they were known pre-1948. These became the four regions after nationalisation. This book is the last of the regions of British Railway, the Southern, covering London and the south-east corner of England. *Volume One* explored London to Cornwall, but in this volume we will be visiting Portsmouth and then journeying along the south coast, taking in the seaside locations which became the playground for Londoners, then Brighton, a favourite seaside resort for royalty and the aristocracy, then Eastbourne, St Leonards and Hastings. We will make a short detour to look at the Romney, Hythe & Dymchurch Railway, before heading back to the main line and Folkestone and the White Cliffs of Dover. Still running close to the sea, we make for Ramsgate and Margate. After Margate we continue to London via Herne Bay and we arrive back in the capital at London Bridge station. After a short break and a sandwich, we will be making more direct journeys to Dover, St Leonards and finally Brighton where our Southern journey will end.

Rex Conway, 2011

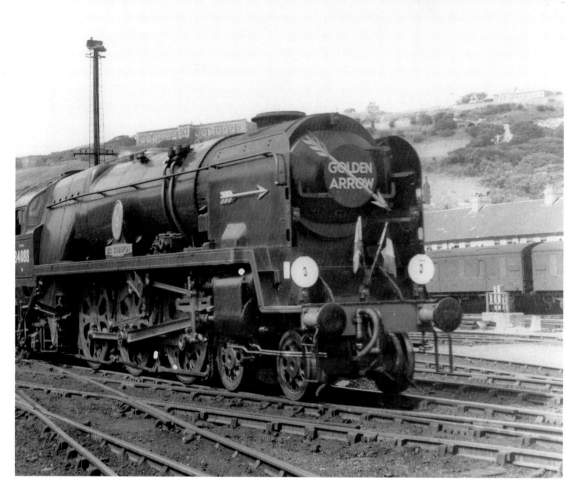

The 'Golden Arrow' express at Dover, headed by 'Battle of Britain' no. 34088 *213 Squadron*.

Rex Conway's Southern Steam Journey

O nce again our band of enthusiasts are assembled at a London main line station for the start of another journey: Waterloo, the Mecca for any Southern worshipper. This journey will be, as all our journeys have been, exciting and full of anticipation as to which steam locos we shall see and record with our cameras, but at the same time there will be a certain amount of sadness as this is our last journey together. As always we make our way to the end of the platform and wait for the carriages of our train for the first part of our journey which is to Portsmouth. And here it comes, with an M7 coasting in, seemingly with little effort, but no doubt with ten carriages it's been working hard bringing the empties from Clapham. All enthusiasts will know the procedure, into the carriage behind the loco, find an empty compartment as near the engine as possible and settle ourselves down, but as usual we are still making sure we can see any arrivals. Our loco has now backed on, it's a light Pacific and we are ready to start our final Southern journey.

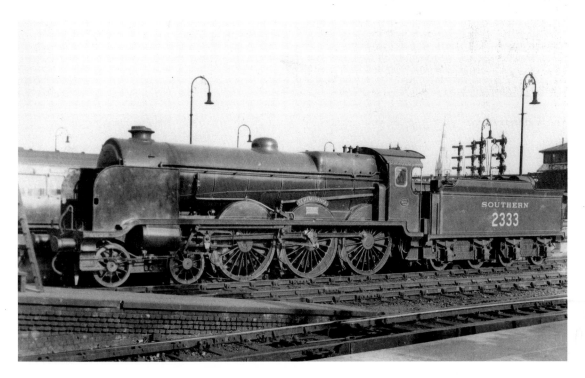

Class N15X 4–6–0 SR no. 2333 *Remembrance*, introduced in 1934. It is a rebuild of a Billington LBSC 4–6–4T that took to the rails in 1914. It is photographed at Waterloo before the Second World War.

We are now settled on the cushions, waiting for the sound of our 'West Country' Pacific hooter, telling us we are about to move, and there it is – we are off. The Bulleid Pacifics have a distinctive soft chuff exhaust sound, quite different to the hard bark from many of the other express locos of the other regions. We are now clearing the platforms and on our way.

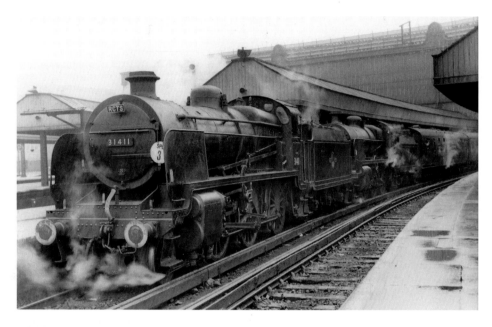

Class N 2–6–0 no. 31411 leaving Waterloo with an RCTS train.

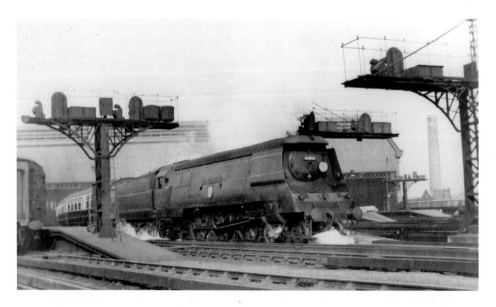

'West Country' 4–6–2 no. 34042 *Dorchester*. I would normally say it blasts its way out of the station, but the reality is that the Bulleids' exhaust is very soft, belying the power of these locomotives. Here *Dorchester* is leaving Waterloo with a Southampton train.

We are approaching Vauxhall and picking up speed, a wonderful station for trainspotting and of course cricket, being the local station for the Oval. Many Test matches have been won and lost at this famous ground, home of Surrey CCC since its foundation in 1845.

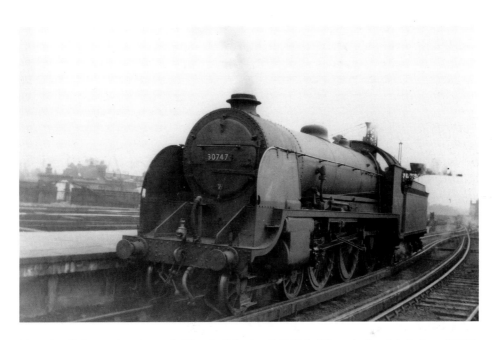

Running light engine through Vauxhall in April 1951 is 'King Arthur' 4–6–0 no. 30747 *Elaine*.

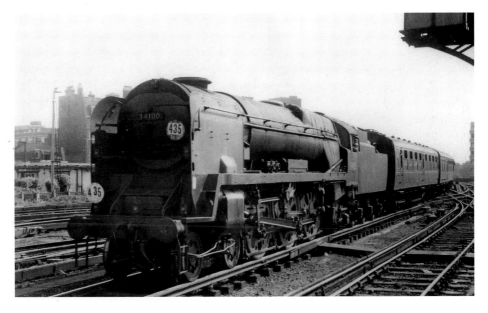

Heading an express to Bournemouth is 4–6–2 rebuilt 'West Country' no. 34100 *Appledore* beginning to build up speed as it heads west through Vauxhall in 1960.

Picking up a bit of speed now, one of our band of enthusiasts tells us that very shortly we will get a view of the main line out of Victoria with trains to the south coast passing under us.

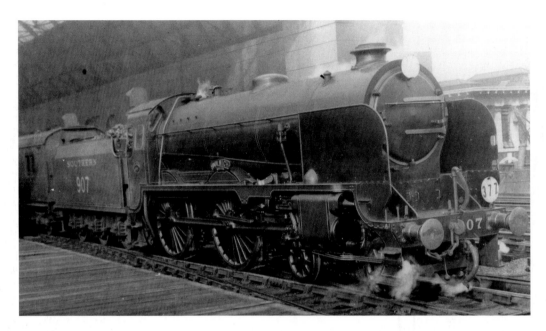

A 4–4–0 V Class built in 1930 by Maunsell. The whole class was named after famous public schools. Weighing in at about 100 tons with its tender, they were among the most powerful and successful 4–4–0s. This view is of no. 907 *Dulwich* at Victoria in the 1930s.

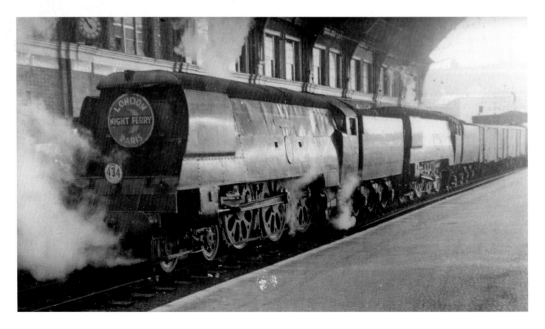

Another view at Victoria is of 'Battle of Britain' no. 34073 *249 Squadron* which has just arrived with the London–Paris 'Night Ferry'.

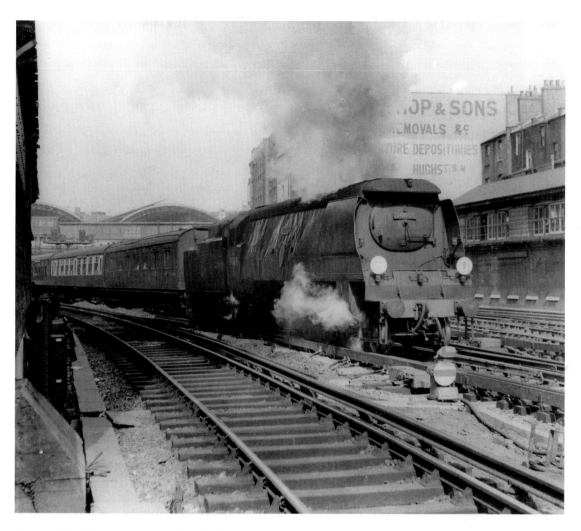

'Battle of Britain' 4–6–2 no. 34068 *Kenley* departing Victoria with a train to Folkestone. Kenley, one of the RAF's famous airfields, was one of the three main fighter airfields that young pilots used to defend London and the Home Counties from the enemy in the Battle of Britain. The airfield also saw action in the First World War, having being established in 1917.

Here we are at Stewarts Lane shed 73A, where nearly all locos in and out of London Victoria came for servicing and coaling, and where crews signed on or off at all hours of the day and night. To enthusiasts visiting this shed, the atmosphere was incredible. There was the smell of smoke and steam and it seemed there were named locos everywhere, including, if you were there at the right time, a view of the engine that was going to haul the 'Golden Arrow' in immaculate condition, with the golden arrows on the smokebox and side of the engine.

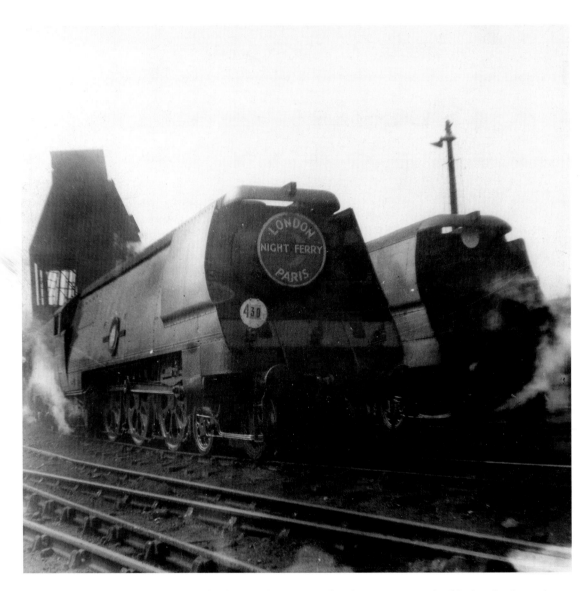

'Merchant Navy' no. 35025 *Brocklebank Line* taking on coal at Stewarts Lane shed before backing down to Victoria to head the London–Paris 'Night Ferry'. The Brocklebank Line was started in 1801 by Thomas Brocklebank with one sailing ship.

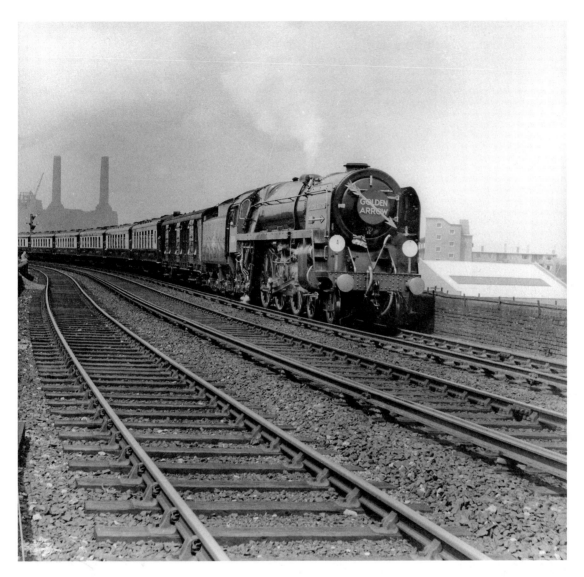

With Battersea power station, built in 1930, forming a background, here is the 'Golden Arrow' headed by 'Britannia' 4–6–2 no. 70004 *William Shakespeare*. Having left Victoria it will make its way to Dover.

All railway enthusiasts know that Clapham Junction is the busiest station in the world, and it will come as no surprise that our group has taken up positions by the windows in the compartment and in the corridor, as we go non-stop through Clapham. Numbers are being called out in a steady stream, but it seems as soon as we approached Clapham, we were through, and on our way to Portsmouth.

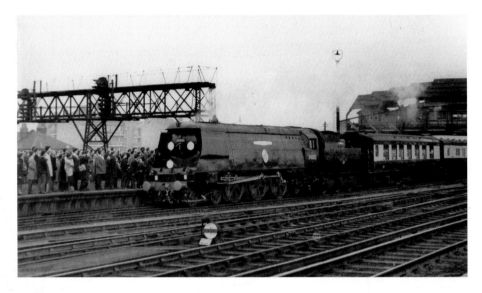

Watched by large crowds, the funeral train of former Prime Minister Sir Winston Churchill makes it steady way through Clapham to his last resting place at Blenheim Palace in 1965. Hauled by 4–6–2 Pacific no. 34051, the engine was named *Winston Churchill* in his honour.

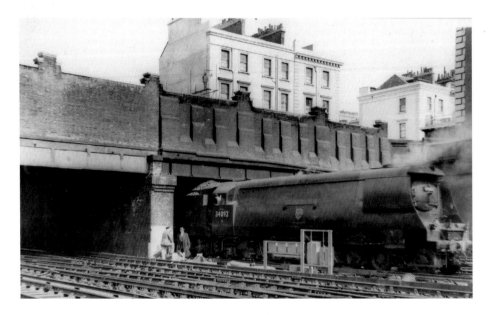

Leaving Clapham is 'West Country' no. 34092 *City of Wells*.

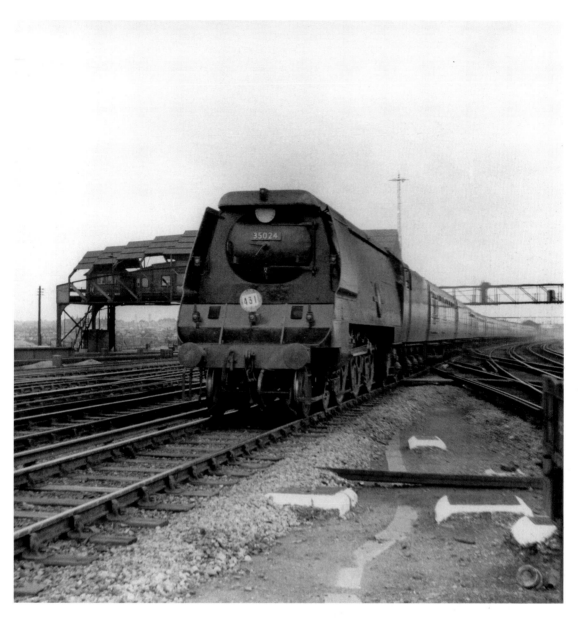

'Merchant Navy' no. 35024 *East Asiatic Company* working its way through Clapham Junction in June 1951.

Clapham Junction is where trains for the south coast and Brighton leave us. As we continue westwards, some calmness returns to our compartment as our train goes through Earlsfield at good speed. We shall soon be passing through Wimbledon, and if you listen hard you can almost hear the crowds encouraging their tennis heroes like Fred Perry who in the 1930s was number one in the world and won the Wimbledon Men's title three times.

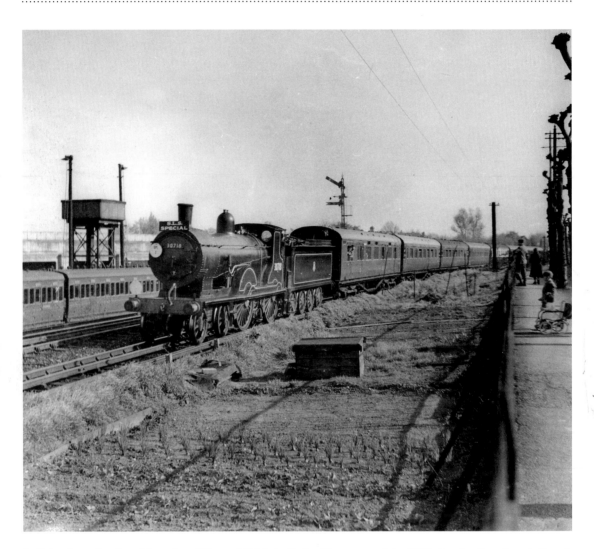

Still in the suburbs of London, T9 no. 30718, built by Drummond in 1899 for the London & South Western Railway, is photographed on an enthusiasts' special at what is considered by many to be the home of tennis, Wimbledon.

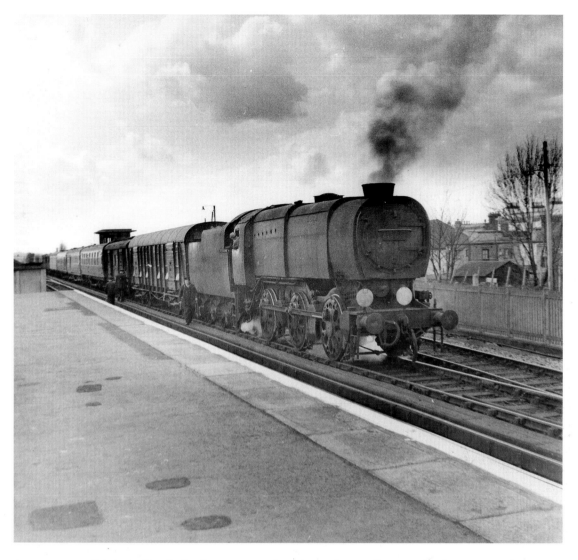

A very successful design by Bulleid in 1942 was his Q1, mechanically a success, but to us enthusiasts it was not a pleasant sight. This view is of 0–6–0 no. 33010 working a train to Norwood Junction through Wimbledon.

At Wimbledon there are several junctions, one that heads south and joins the Brighton line and the Norwood freight yards, and another to Mitcham.

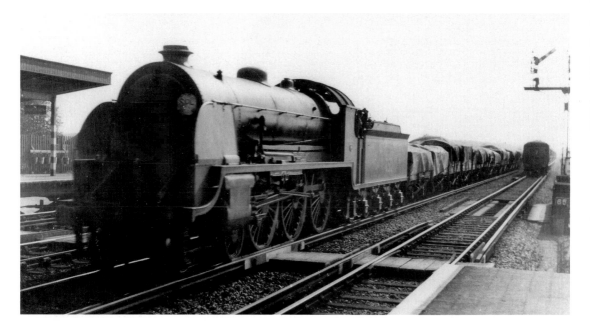

Southern N15 4–6–0 'King Arthur' no. 750 *Morgan Le Fay* near Wimbledon in the 1930s heading for Norwood yards.

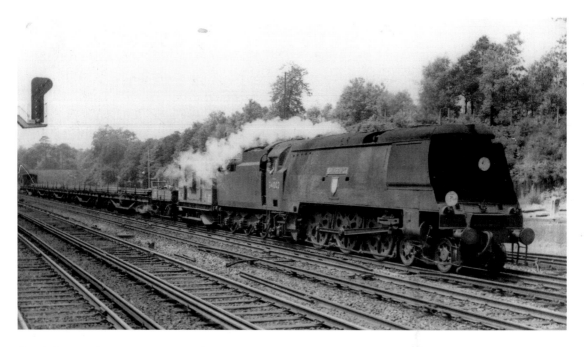

'West Country' 4–6–2 no. 34002 *Salisbury* working a Battersea–Norwood freight via Crystal Palace.

Running nicely now, we shall very shortly be through Raynes Park, where we may see something as I am told its quite a busy junction, with a line heading off on the left to carry horse racing lovers to Epsom.

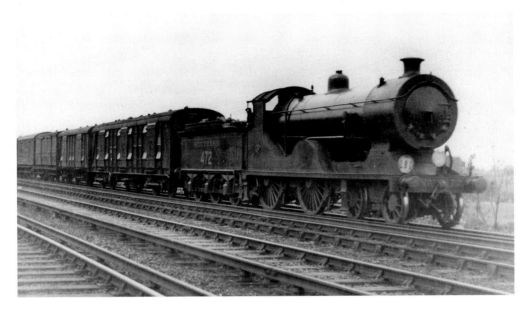

Near Raynes Park is this pre-Second World War view of D15 4–4–0 no. 472, a Drummond design for the L&SWR in 1912.

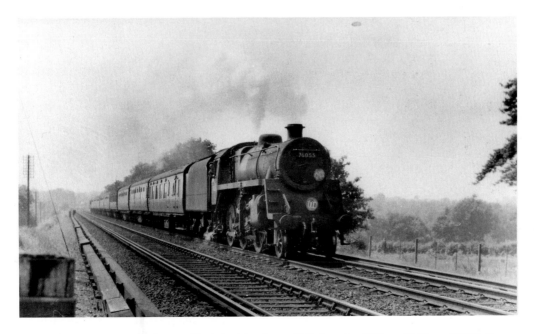

A much later view near Raynes Park is this view of BR Standard Class 4MT no. 76055. It was photographed in 1955 with a Portsmouth train.

It won't be long now before we stop at Surbiton to pick up more passengers, but before that, we pass through a busy junction at New Malden, heading north to Twickenham, the home of English rugby.

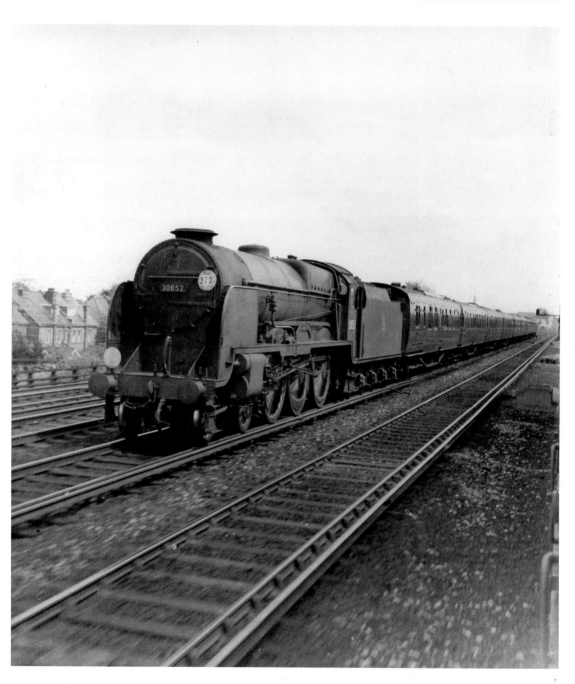

Heading through Surbiton with a Bournemouth-bound express is Lord Nelson 4–6–0 no. 30852 *Sir Walter Raleigh*, famous for introducing among many things, tobacco to this country.

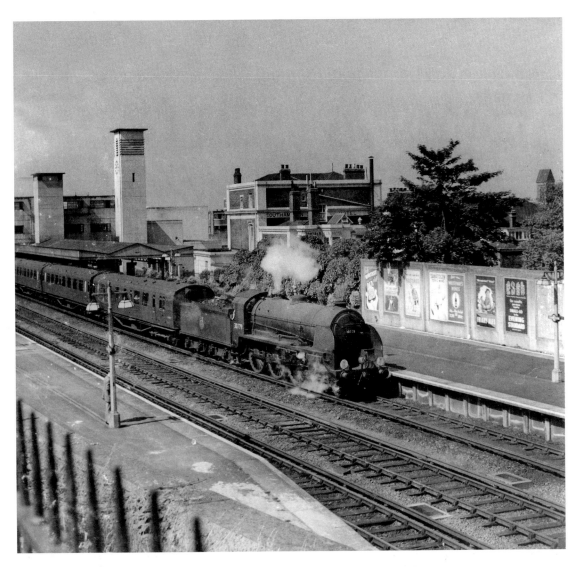

Picking up passengers at Surbiton is 'King Arthur' no. 30779 *Sir Colgrevance* with a Bournemouth train.

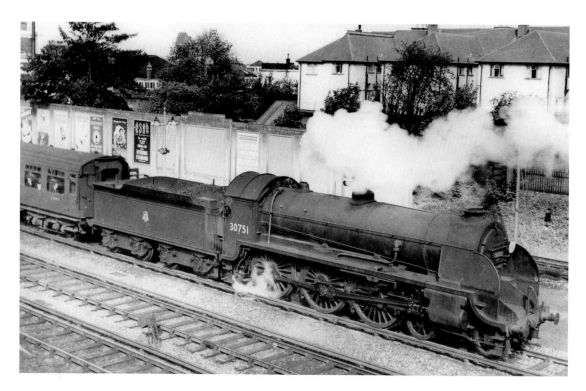

Another 'King Arthur' 4–6–0 picking up passengers at Surbiton is no. 30751 *Etarre*.

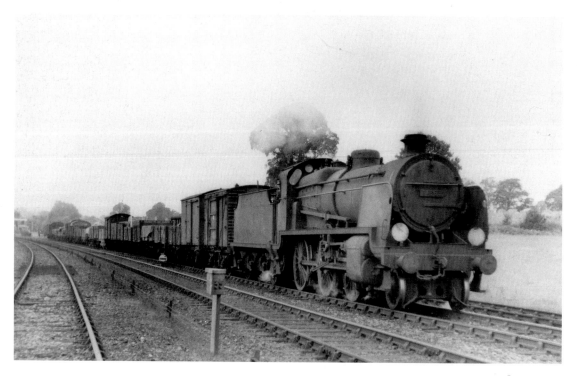

N Class 2–6–0 no. 31863 with a mixed freight near Hampton Court Junction.

We have left Surbiton with some fresh passengers, and we are on our way again, to the soft sound of the exhaust of our 'West Country'. We shall soon be passing through Hampton Court Junction and then Esher. We can now relax and do what all railway enthusiasts do, talk and enjoy a sandwich and a drink.

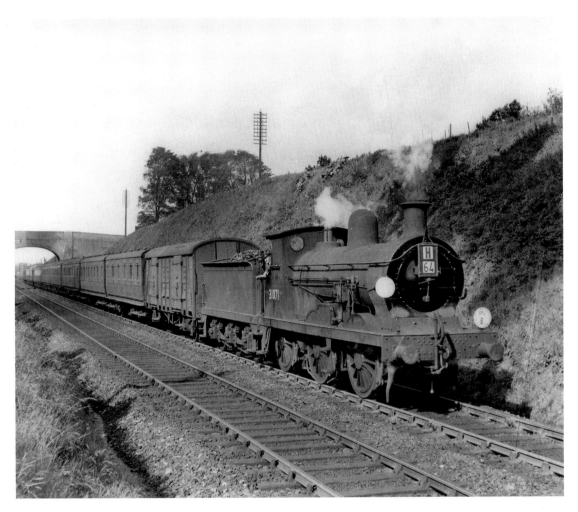

C Class 0–6–0 no. 31071, a Wainwright design for the SECR in 1900, photographed near Esher in 1956.

During all the talking in our compartment, our Southern specialist tells us about the next junction we will come to, Weybridge, where a line leaves the main route west and heads north to Virginia Water and Staines. Here another junction will see many goods trains heading for the big yards at Feltham and others towards Reading.

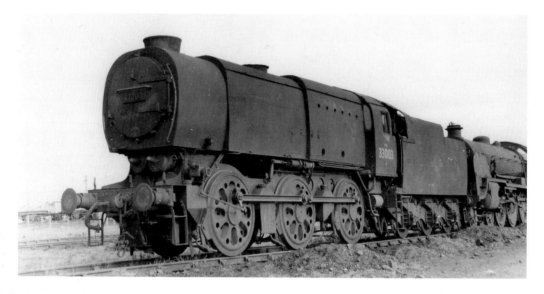

Waiting for its next duty is Q1 no. 33003 on Feltham shed in February 1964.

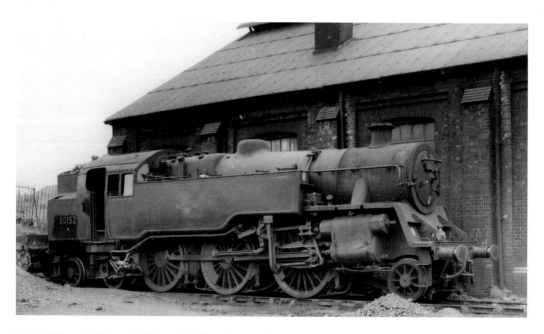

2–6–4 Class 4MT no. 80152, a Riddles design for British Railways built at Brighton, weighing in at nearly 90 tons. They are very capable engines hauling freight or passenger trains. It is photographed here at Feltham.

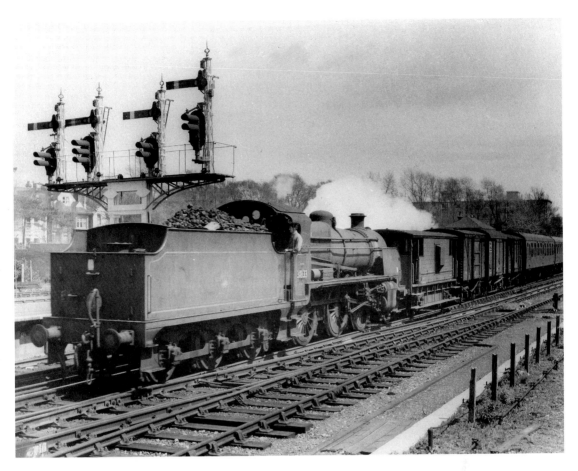

2–6–0 N Class no. 31833, a mixed traffic loco that first saw life in 1917. It is seen here working a mixed freight near Feltham.

Reading of course was principally a Western region stronghold, but it was also an interchange point. Trains of freight or passengers came from the Southern and could then be taken north to Birmingham or further via Oxford or Princes Risborough.

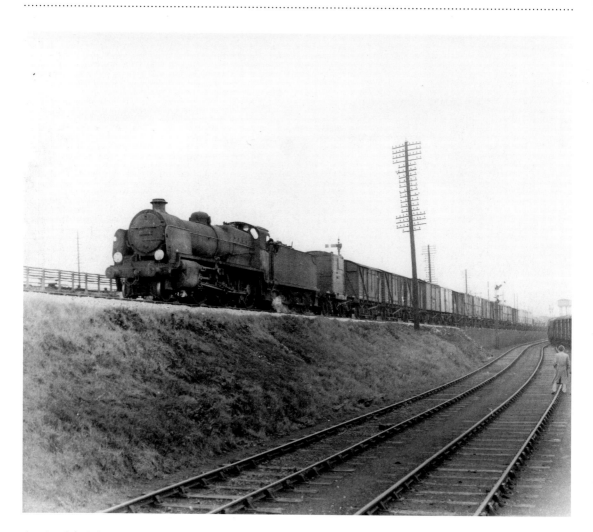

A mixed freight train at Reading, headed by N Class 2–6–0 no. 31851. This photograph was taken on 25 February 1961.

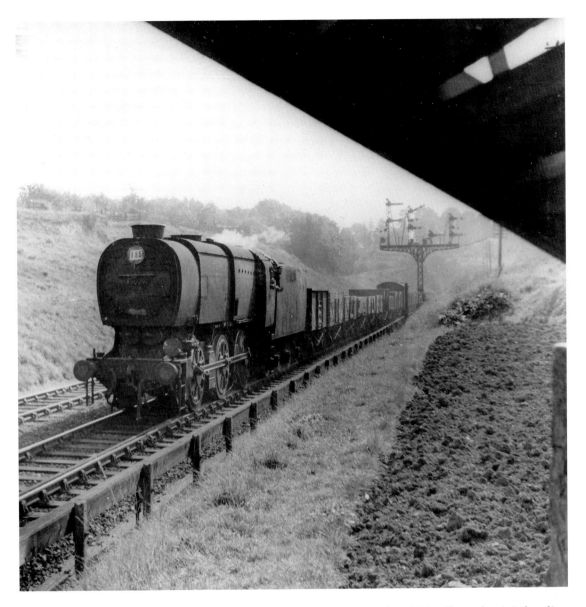

Near Woking is this view of Q1 0–6–0 no. 33027 carrying a headcode which tells us that it is heading for Reading.

We are through Weybridge, still travelling at a fair speed, although we shall soon be slowing for Woking where just past the station we shall leave the West of England line and head south for Portsmouth. There will not be much to see until we get to Guildford, so we can take stock, update our notebooks and look at the countryside in lovely sunshine, with smoke and steam drifting past the window. What more could you ask for?

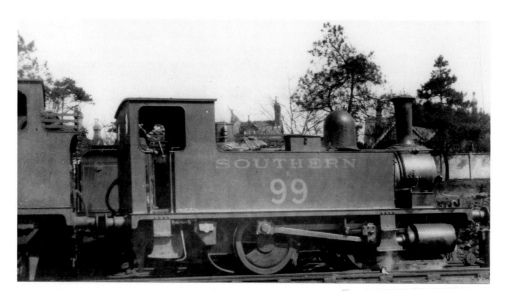

Diminutive dock shunter B4 0–4–0T built in 1891 by Adams for the L&SWR, with a very short wheelbase. It was an ideal engine for working the docks area such as Southampton. This view is of no. 99 in Southern Railway days photographed at Guildford.

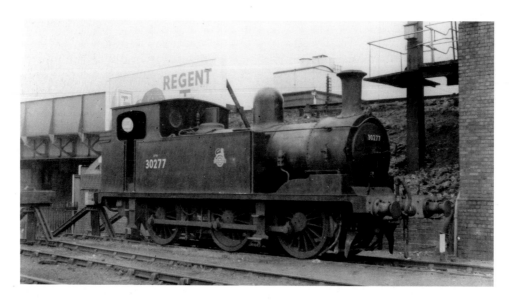

Another view of an elderly loco on Guildford shed. This is of a larger tank engine G6 0–6–0T no. 30277 again, built in the 1890s by Adams for the L&SWR.

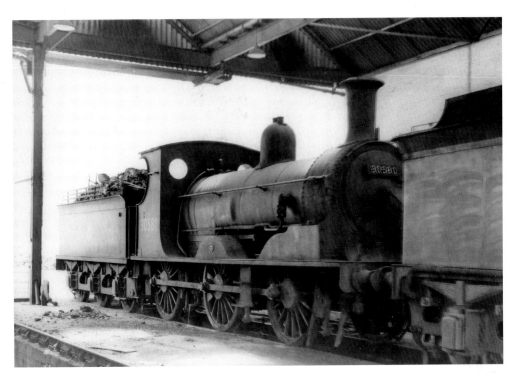

Far from being a youngster, 0–6–0 Class 0395 no. 30580 first saw life in 1881, another Adams engine for the L&SWR, photographed resting on Guildford 70C shed in 1955.

S15 Class 4–6–0 no. 30836 waiting in the centre road at Guildford station.

Leaving Guildford behind, but not before we added a few more numbers to our notebooks, and took a few more photographs, our 'West Country' is keeping up a good speed through Shalford Junction where the old South Eastern & Chatham Railway line makes its way to Dorking. Then, a few miles further on, comes Peasmarsh Junction, this time with a London, Brighton & South Coast Railway line heading for Brighton – but we continue heading for Portsmouth via Godalming.

A double-headed passenger train at Godalming, headed by two Class 700 4F 0–6–0s designed by Drummond in 1897 for the L&SWR. The lead engine is no. 30693.

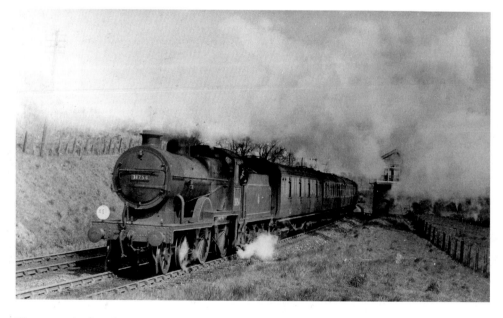

Photographed in the countryside near Midhurst is L1 Class 4–4–0 no. 31754.

After Godalming comes a few miles with only country stations: Haslemere, Liphook, Liss and then Petersfield with a junction to Midhurst.

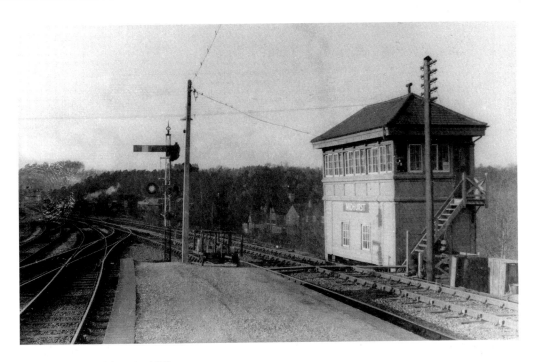

Midhurst signal-box in 1951.

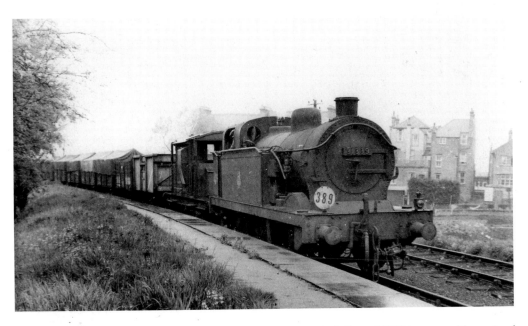

A Stirling design for the South Eastern Railway in 1888, 0–6–T no. 31339 is seen with a mixed freight at Midhurst.

We are on the last few miles of our journey to Portsmouth as we approach Havant Junction, where a branch line makes its way across the water to Hayling Island. Our Southern expert tells us that it is a true island, famous for its oyster beds. It also saw much activity during the Second World War as the Allies practised landings there in preparation for D-Day.

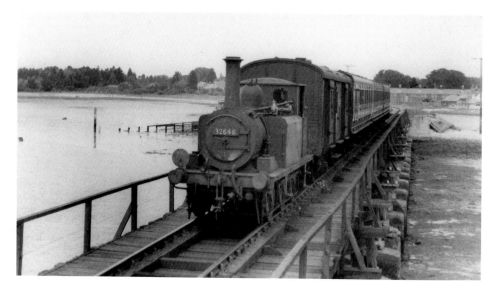

Crossing the Langston Bridge to Hayling Island is 0–6–0 AIX Class no. 32646. This class of loco was first seen in 1872 to a Stroudley design for the LB&SCR. In 1911, when Marsh was in charge, they were rebuilt with a new boiler and extended smokebox.

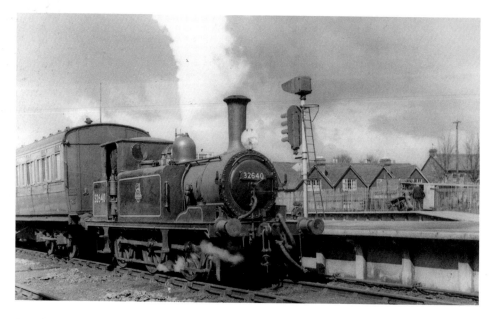

Emphasising how small this class of loco was is this view of AIX no. 32640 in Havant station, dwarfed by the carriages of its train.

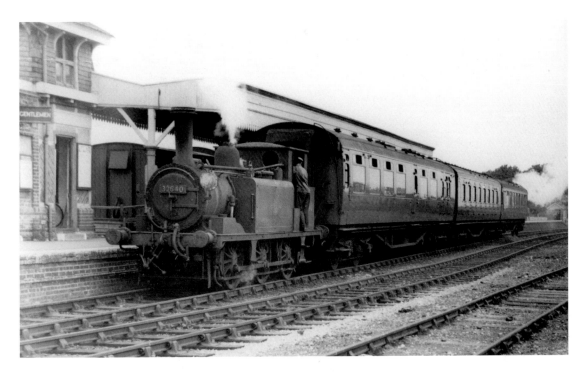

Another view of Hayling Island station with A1X 0–6–0T no. 32640 waiting patiently for the signal to be given for its return to Havant on the mainland.

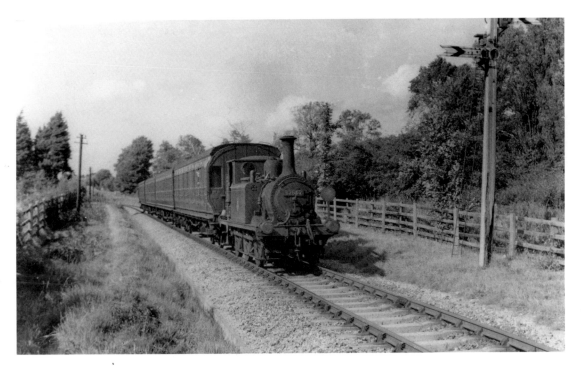

A1X no. 32662 in the countryside of Hayling Island. I like the cost-cutting signal with two arms controlling trains in either direction on the single line.

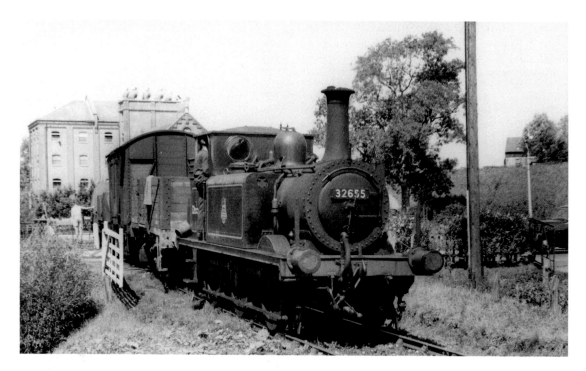

Basking in summer sunshine on the Island line is A1X no. 32655.

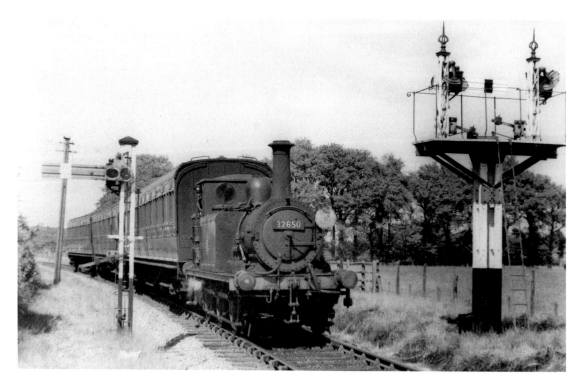

On its way back to Havant, perhaps on the same day as the above photograph, is A1X no. 32650 also in summer sunshine.

A voice from the corner of our compartment tells us to look out for Fratton shed which comes just before we roll to a stop in Portsmouth. Fratton supplied the motive power for trains from Portsmouth to all parts of the Southern system.

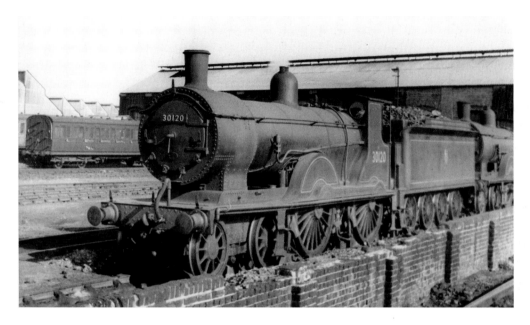

Fratton shed 71D, just outside Portsmouth, had a good and varied selection of locos, some for local working, but many for working London and south coast trains. Here T9 4–4–0 no. 30120 awaits its next call for duty.

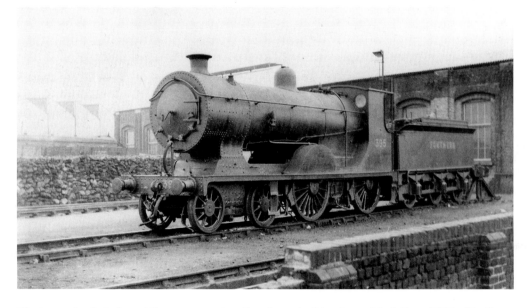

Photographed at almost the same spot as the above is this view of 4–4–0 no. 395 in Southern days in the 1930s.

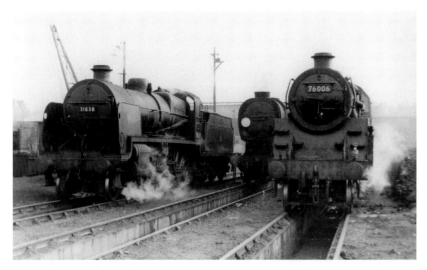

Posed on Fratton shed is 2–6–0 U Class no. 31638. Its stable companions are Q1 no. 33001 and Standard Class 4MT no. 76006.

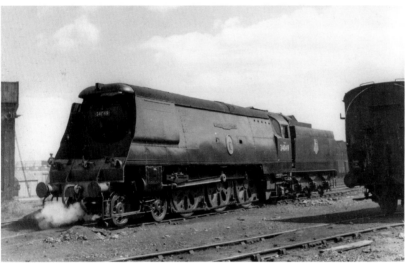

'Battle of Britain' no. 34049 *Anti-Aircraft Command* on Fratton shed after working a Waterloo–Portsmouth train.

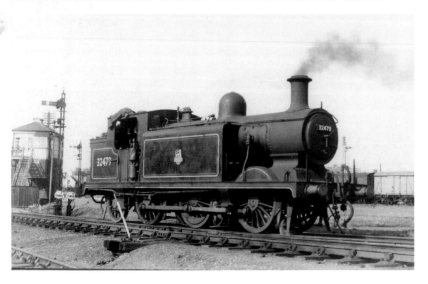

E4 Class no. 32479, an 0–6–2T Billington design for the LB&SCR.

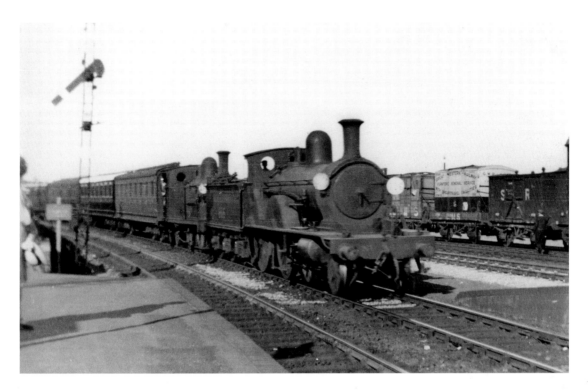

Arriving at Fratton in this pre-war view is an unidentified 4–4–0.

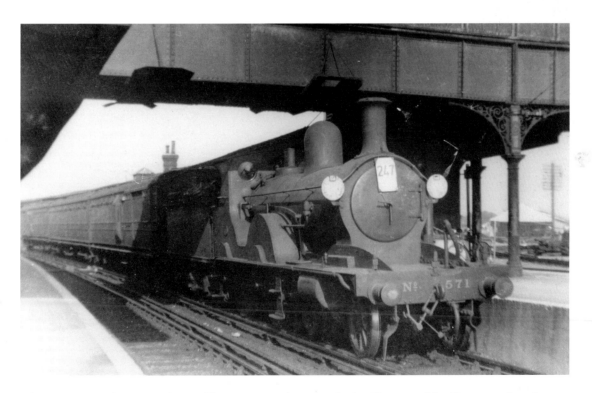

Also pre-war is this view of 0395 Class no. 571, photographed at Fratton with a Portsmouth train.

Portsmouth, of course, is a large Royal Navy base, with many service personnel using the trains, especially to London. There is also a ferry service to the Isle of Wight, France and the Channel Islands.

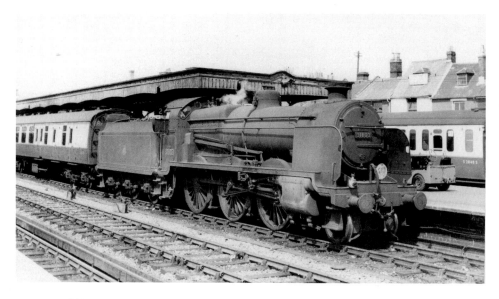

U Class no. 31803 simmering quietly in Portsmouth station.

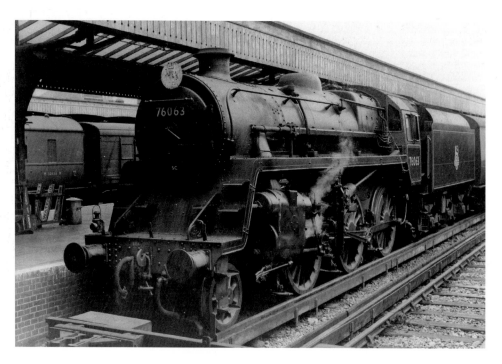

Portsmouth station is the setting for this view of British Railways Standard Class 4MT no. 76063, having arrived with a London Bridge–Portsmouth train.

We are now leaving Portsmouth to continue our journey along the south coast. We have changed engines, from a 'West Country' to a U Class 2–6–0. Again, a few noses are pressed against the windows as we pass Fratton sheds. Next comes Farlington Junction, then we are through Havant Junction and on our way to Brighton. The train is not far from the sea and we catch occasional glimpses of it. Our train is now approaching Chichester with its junction to Midhurst in the north, and Selsey in the south. Coming up is another junction with lines to Littlehampton and Pulborough. We push through Worthing and then comes Shoreham.

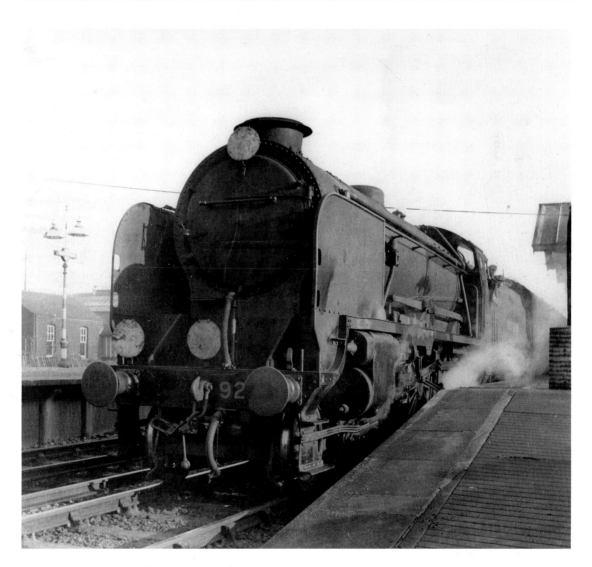

'Schools' 4–4–0 no. 929 *Malvern* picking up passengers at Worthing in the 1930s. Malvern College was taken over for a period during the Second World War for secret war work, the school moving temporarily to Blenheim Palace.

At Shoreham a junction heads north to West Grinstead, Christs Hospital and eventually back to London.

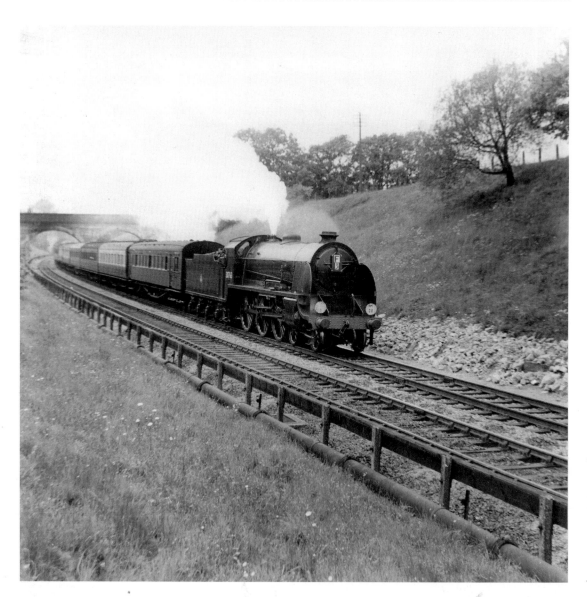

'King Arthur' no. 30763 *Sir Bors de Ganis* near West Grinstead on its way to Shoreham in May 1953.

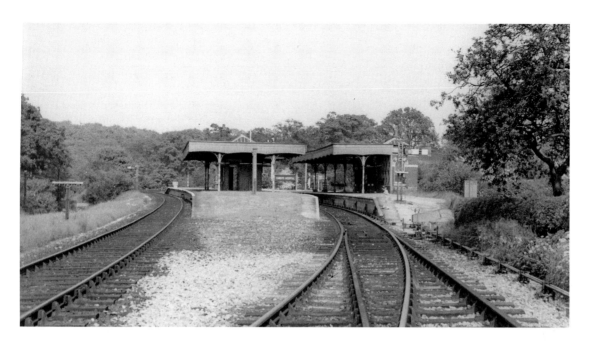

A view of Christs Hospital station. No doubt there will be many scholars who remember this station with joy at the start of the school holidays, or trepidation as they arrive to start life at Christs Hospital boarding school. Founded nearly 500 years ago, its most famous pupil was Sir Barnes Wallis, the famous inventor of the bouncing bomb used in the attacks on the Möhne Dam.

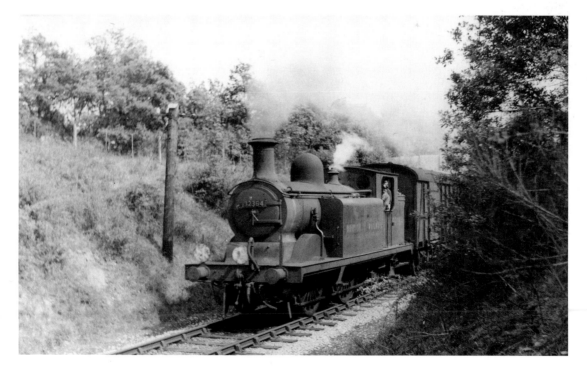

Not far from Christs Hospital is Slinfold where this photograph of 0–4–4T no. 32364 was taken, a D15 Class loco built by Drummond for the L&SWR in 1912.

Three more views near Horsham, a few miles east of Christs Hospital, heading towards
Three Bridges.

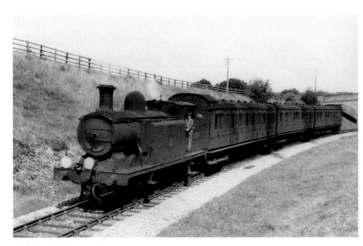

E4 0–6–2T no. 32517 with a three-coach local passenger train from Guildford to Horsham.

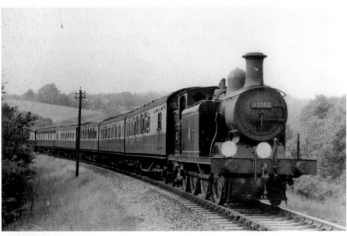

Another E4 heading for Horsham with a passenger train from Guildford is no. 32566.

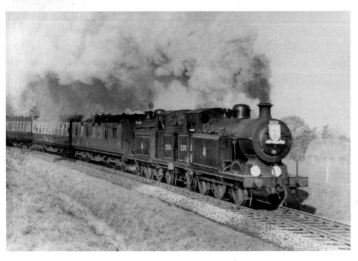

An E4 lookalike is E5X no. 32566, although the boiler and wheels are slightly bigger than the E4's, and it weighs nearly 3 tons more. It is seen here near Horsham with a RCTS special. It is also being assisted by another E5X, no. 32576, running bunker first.

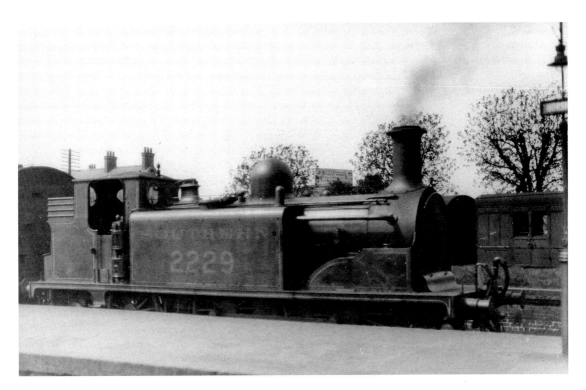

Horsham station is the setting for Southern Railway no. 2229 simmering quietly in spring sunshine in the 1930s.

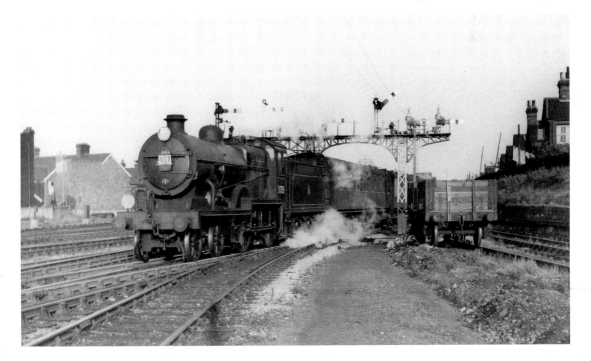

L1 4–4–0 no. 31785 leaving Horsham with a train to Portsmouth.

Shoreham has a number of stations including Shoreham LB&SCR opened in 1840, and Shoreham SECR in 1862. There was also a Shoreham Airport Halt, opened in 1938, and another LB&SCR station is Shoreham-by-Sea, where pupils for Lancing College would alight. Indeed, 'Schools' class no. 30904 carries the name *Lancing*.

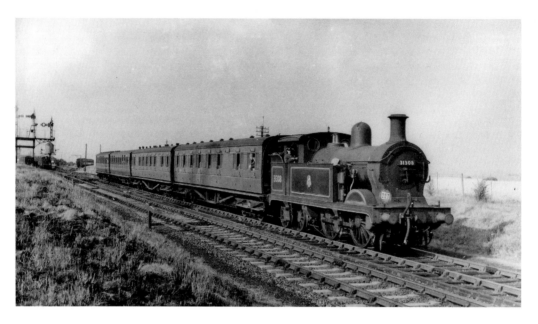

Class H 0–4–4T no. 31308 near Shoreham in 1955.

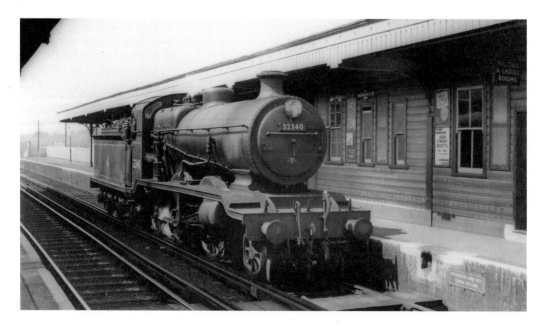

A 1913 Billington design for the LB&SCR is K Class 2–6–0 no. 32340 light engine in Southwick station.

Through Southwick the stations come thick and fast – there's no time to sit down as we pass through Fishergate and then Portslade Dyke Junction where there is a short single line to the Dyke. We shall soon be in Brighton, where we shall change trains for the next part of our journey.

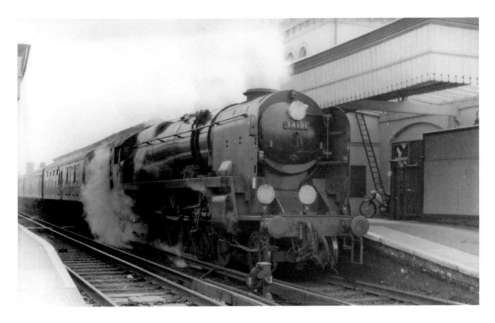

Portslade, between Shoreham and Brighton, supplies the background for this view of 'West Country' no. 34101 *Hartland* with a Brighton–Salisbury train via Southampton.

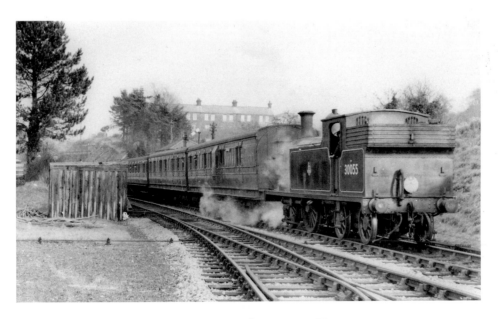

Dyke Junction is the setting for this view of M7 no. 30055.

We have started collecting all our gear ready for our departure from this train, as the next part of our journey will be a fresh loco and another set of carriages. But before that we shall be visiting Brighton works and shed, something we are all looking forward to.

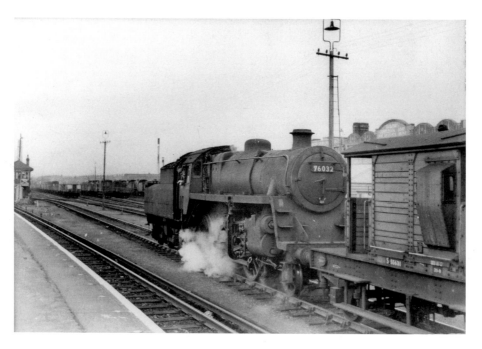

Passing through Hove station is Standard Class 4MT 2–6–0 no. 76032.

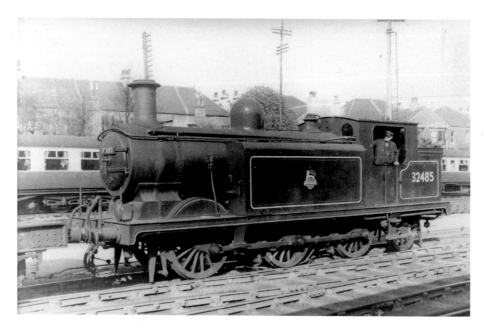

Photographed stationary in Hove station is E4 0–6–2T no. 32485.

With the familiar sound of the brakes being applied, we are rapidly slowing as we approach Brighton station and with a slight jerk we come to a halt. In seconds we are on the platform and making our way to the works and shed.

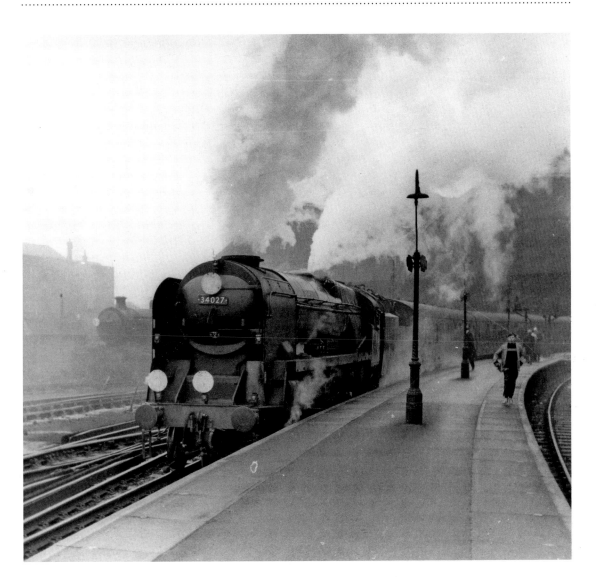

'West Country' 4–6–2 no. 34027 *Taw Valley* starts a Salisbury-bound train out of Brighton terminus station.

Brighton works was built in 1840 by the London & Brighton Railway as it was known in those early days. It was built right next to Brighton station, so it won't take us more than a few minutes to get there. Clutching works and shed passes we are soon into the large area, with locos in many bits. We are under the guidance of a gentleman who started at Brighton works many years ago, and could answer any questions we asked.

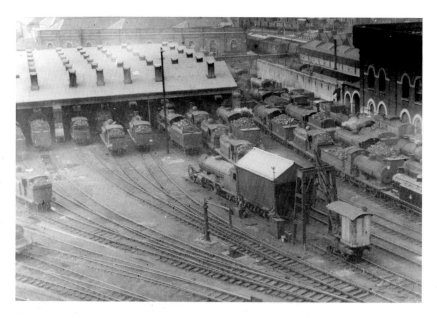

There were plenty of locos on Brighton shed when this photograph was taken in May 1950.

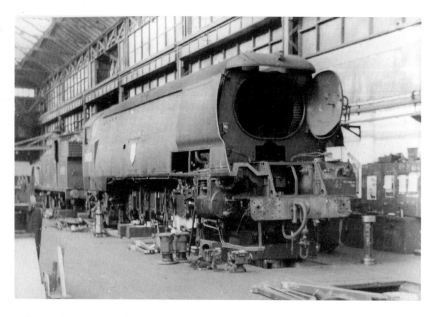

A 'West Country' in for overhaul in Brighton works is no. 34020 *Seaton*.

One question asked of our guide was 'when was the first loco built here?' The answer was in 1852 by the London, Brighton & South Coast Railway as the company had become known. He went on to tell us the works covers 9 acres, and has built well over a thousand locos. During the Second World War, Brighton, as with other large railway works, undertook war work, producing parts for tanks, guns and many other items essential to the war effort.

On Brighton shed 75A in 1953 is this Class H2 Atlantic 4–4–2 no. 32426 *St Albans Head*.

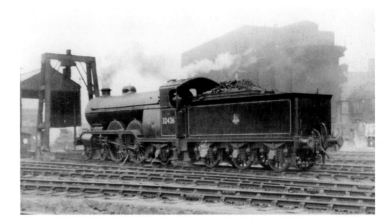

'Leader' no. 36001 was the only one of this Bulleid experimental class to run. Four more were being built but without success, and all were scrapped in 1951. They were 0–6–6–0 articulated locos with double-end cabs, but the fireman in the middle suffered badly from cramped conditions and a very hot cab.

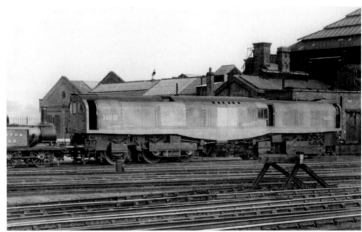

'Battle of Britain' 4–6–2 no. 34110 *66 Squadron* fresh out of Brighton works.

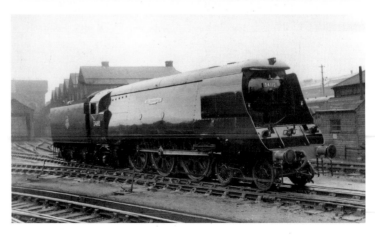

Our guide was asked many questions by our group, but the answer to one in particular amazed us. Apparently during the Second World War the works completed one 'Austerity' class 2–8–0 steam engine every four days for the War Office. With such an astounding feat in mind, we say our goodbyes to our guide, and make our way to Brighton shed.

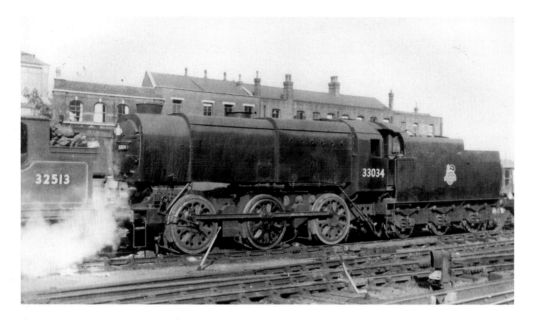

Q1, Bulleid's answer to wartime austerity, built in 1942 when there was a chronic shortage of materials. It was a very successful mixed traffic loco, but regrettably not very pleasing to the eye. Here, no. 33034 simmers in the yard at Brighton.

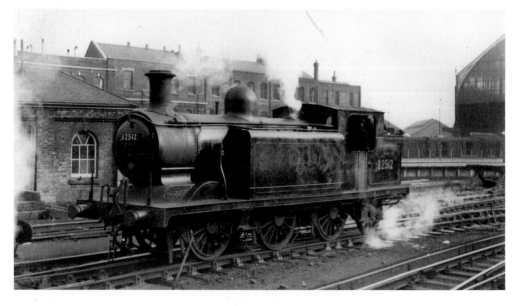

Far more attractive is Billington's E4 0–6–2T no. 32512, also in the yard at Brighton.

'Schools' V no. 30900 *Eton* waiting for its next duty at Brighton. The first name to be adopted by the 'Schools' class, Eton was founded in 1440 by Henry VI.

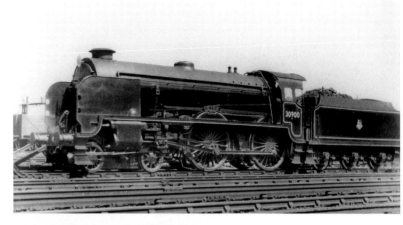

One of the Southern Atlantics, H2 4–4–2 no. 32426 *St Albans Head* on Brighton shed in 1950.

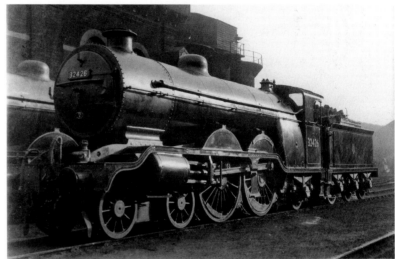

Another Class H2 Atlantic 4–4–2, no. 32424 *Beachy Head*, about to leave Brighton with an RCTS special.

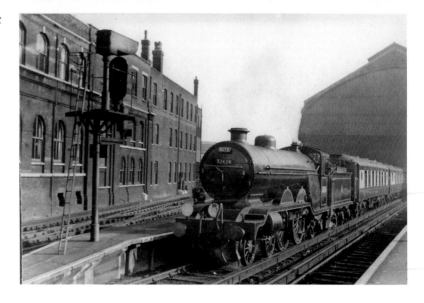

It's time for us to leave the works and sheds which has been a wonderful experience, as with all such visits on any region. To a non-railway enthusiast, the unappealing noise and smells of these works are to be avoided at all costs, but to us it is like a dream come true.

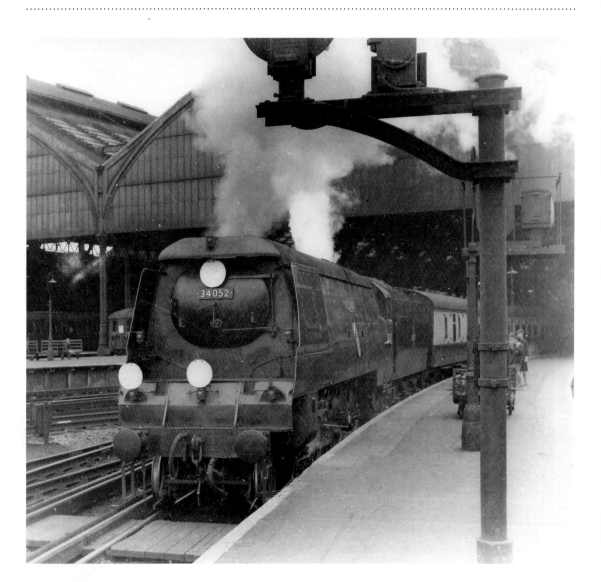

'Battle of Britain' 4–6–2 no. 34052 *Lord Dowding* was named after the head of Fighter Command. Without his brilliance and leadership of the pilots of the fighter wings, who knows what the outcome of the war would have been? Here his namesake is leaving Brighton with a Salisbury-bound train.

We are back on the train that will take us on the next part of our journey along the south coast and then back north to Margate, from where we will be returning to London. We have found another empty compartment behind the engine which has just backed on, and is another 'Spam Can' as the unrebuilt Bulleids have been named, rather unkindly. I think they look very smart and powerful, but not up to my own favourites, the 'King' and 'Castle' classes of the Western – but I am a West Country man, so what would you expect? On our way now, it is time to get the drinks and sandwiches out as we have twenty minutes or so before we get to Lewes.

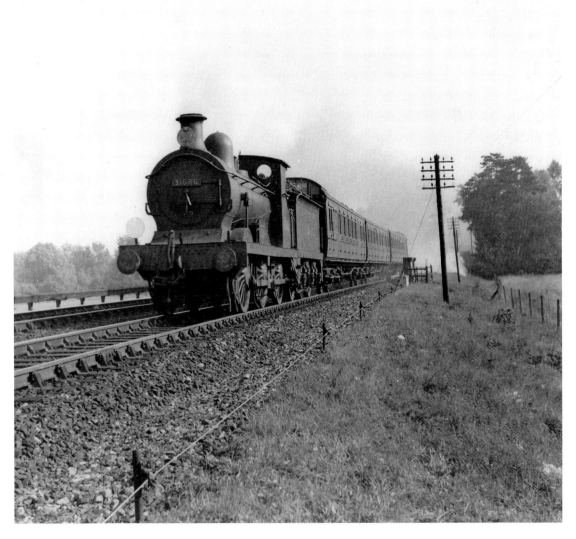

C Class 0–6–0 no. 31686, built in 1900 to a Wainwright design for the SECR, is photographed on the main line near Lewes with a three-coach stopping train.

Lewes is the next station of interest, built by the LB&SCR. In the 1840s it was an interesting and busy station with lines coming in from Three Bridges, East Grinstead, Tunbridge Wells West and, of course, the main line from Brighton, which we are travelling on. Going south is the junction to Newhaven.

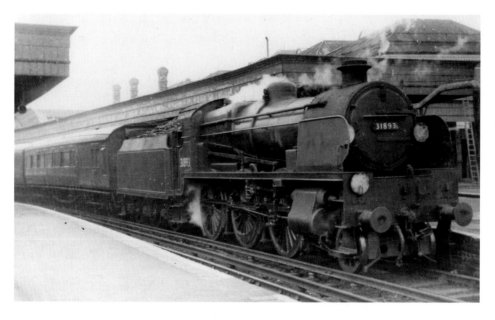

Lewes station is the setting for this view of Ul Class no. 31893.

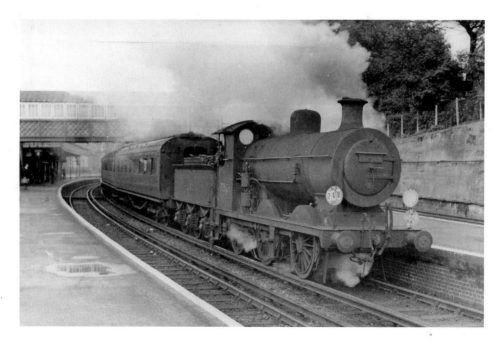

Another station photograph at Lewes is this view of C2X no. 32529.

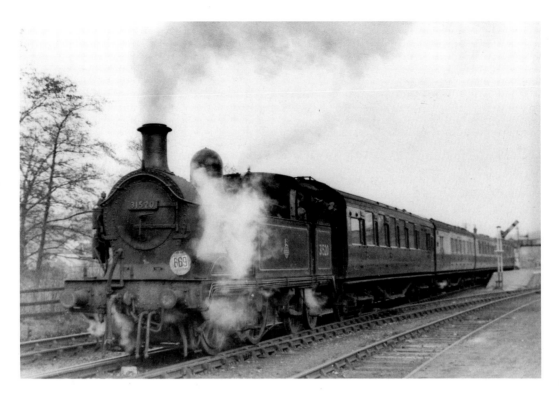

H Class 0–4–4T no. 31520 was a Wainwright design introduced in 1904 for the SECR. It is seen here leaving Uckfield station in 1952 on the Lewes–Tunbridge Wells line.

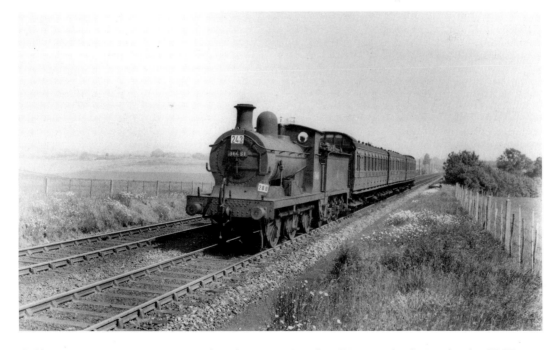

C Class 0–6–0 no. 31461 was introduced in 1900. Another Wainwright design for the SECR, it is photographed near Lewes.

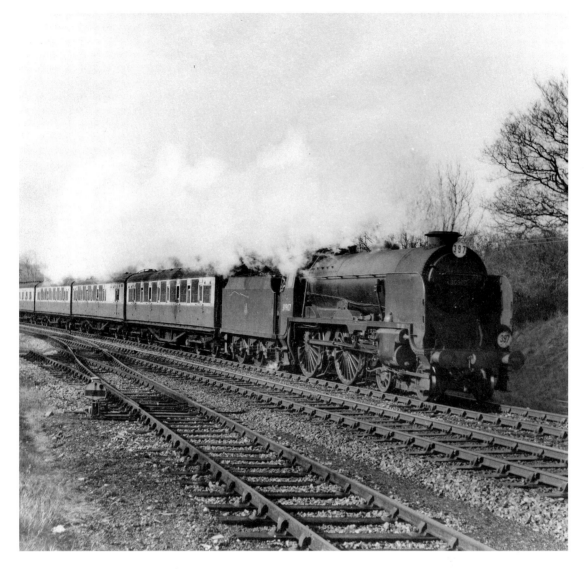

'Schools' 4–4–0 no. 30907 *Dulwich* near Lewes in 1955.

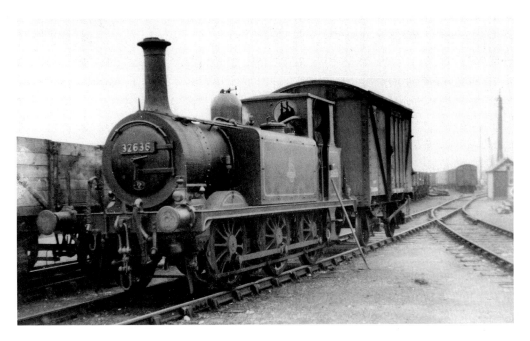

One of the oldest classes of locos still working is the small A1X 0–6–0T, weighing a mere 27 tons and built in 1872 to a Stroudley design. Here no. 32636 is shunting in the yard at Newhaven in 1952.

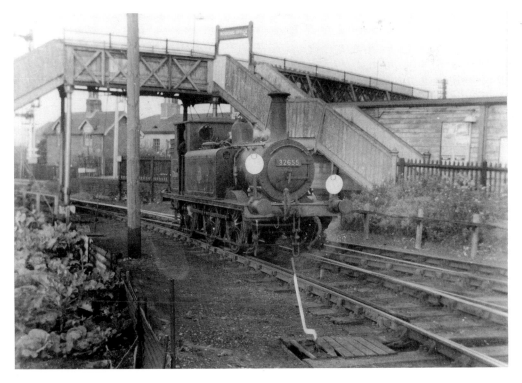

Newhaven station is where A1X no. 32655 was photographed in October 1956.

Making steady progress with our 'West Country' 4–6–2 we shall soon be approaching Polegate,
yet another junction heading back towards London via Tonbridge. We, of course, will continue
steaming towards the next junction east of Polegate where the line diverges to the right, heading
south to the popular resort of Eastbourne.

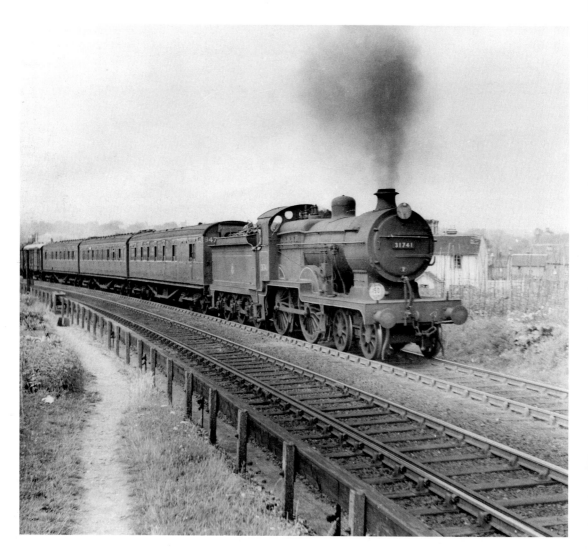

Photographed at Mayfield on the line from Polegate to Tonbridge is this view of Dl 4–4–0 no. 31741,
a Wainwright design for the SECR.

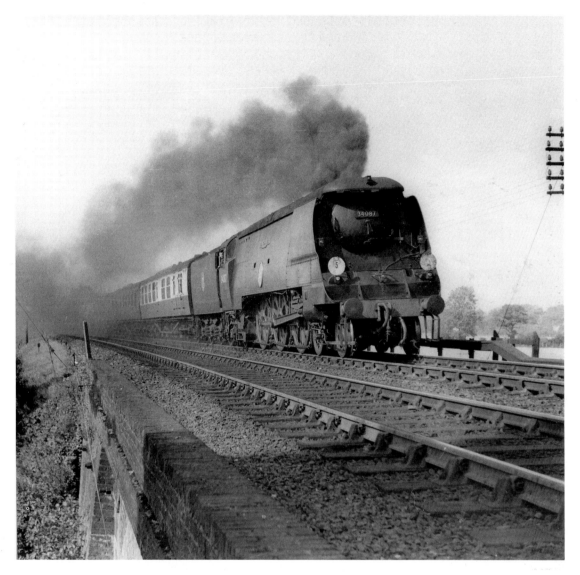

'Battle of Britain' no. 34087 *45 Squadron* near Polegate.

Eastbourne was a popular holiday resort for Victorians who wanted a nice relaxing holiday by the sea. However, to have a few days in the sun in the early nineteenth century required a journey by stagecoach, and it wasn't until the arrival of the railway in 1866 that Eastbourne changed from a sleepy village to a fast-growing holiday resort. Eastbourne station has a very impressive frontage which includes a large clock tower.

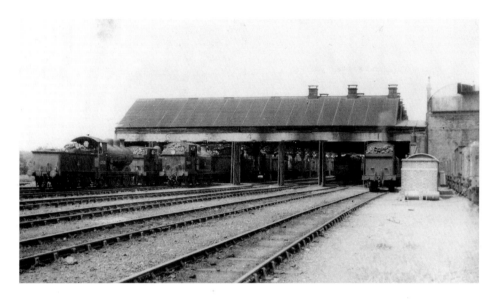

Eastbourne shed 75G photographed in May 1950.

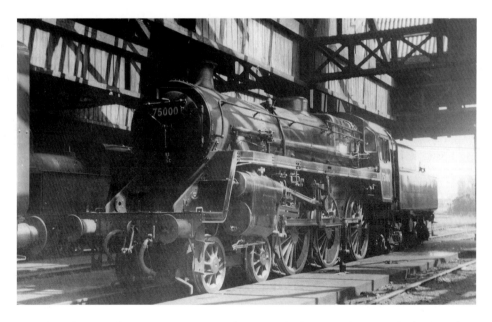

British Railways Class 4MT no. 75000, photographed on Eastbourne shed. This class of loco was designed at Brighton, where many were built. Carrying an 82C Swindon shedplate, it is a bit off its Western region territory.

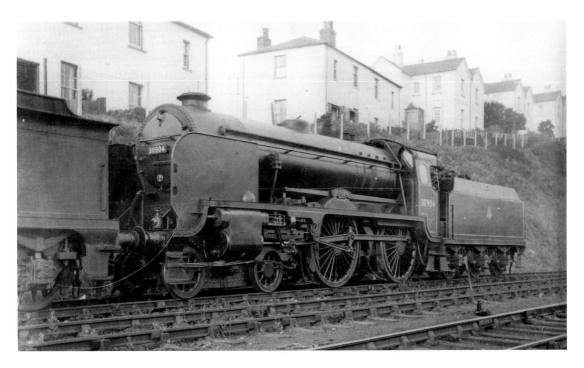

Another view of Eastbourne shed with 'Schools' 4–4–0 no. 30904 *Lancing* posed nicely for the camera. It has probably brought in a train from London.

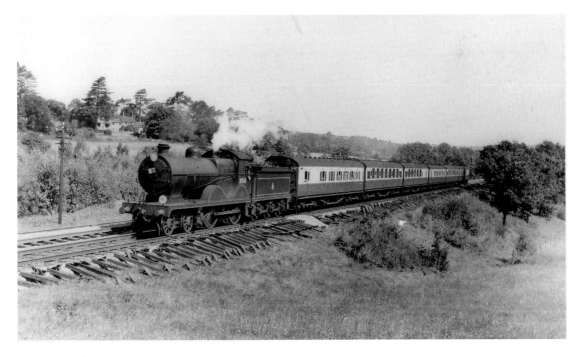

Nearing the end of its journey from London to Eastbourne is L Class 4–4–0 no. 31765 built in 1914 at the start of the First World War. A Wainwright design for the SECR, it had 6ft 8in wheels, and nearly 20,000lb tractive effort. They were very capable locomotives.

Railway enthusiasts are a hardy breed and we will follow our love for steam engines anywhere in all weathers; snow (which of course can make lovely pictures), pouring rain (which does not) and glorious sunshine, which we are blessed with on our journey. This is fortunate because we are now approaching the part of the line that runs beside the sea. We are now through Pevensey and then come several small stations where we are treated to a view of a blue sea. Next we pass through Bexhill-on-Sea, and then the brakes come on and our train comes to a halt in St Leonards Warrior Square.

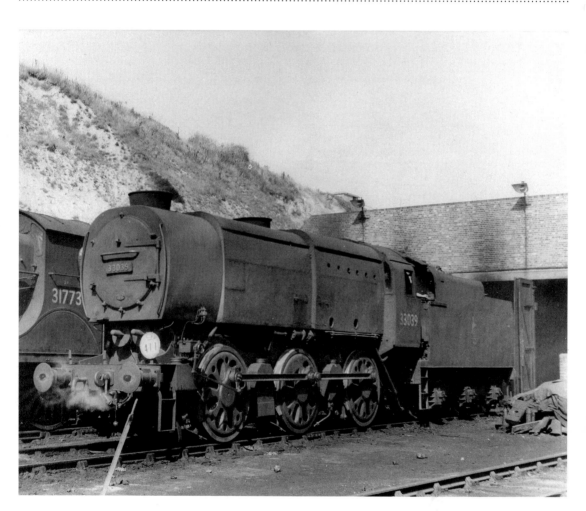

St Leonards shed 74E is the setting for this photograph of Q1 no. 33039.

St Leonards Warrior Square was built for the South Eastern Railway in 1852 by William Tress to a semi-Classical design, similar to Robertsbridge which was also by Tress.

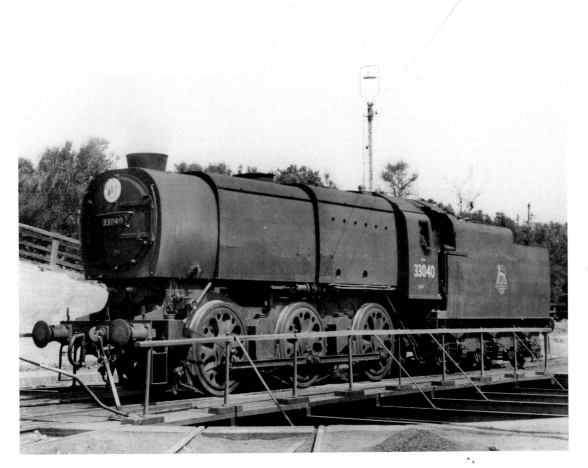

A locomotive on the shed turntable at St Leonards on a summer's day in 1954. Ql 0–6–0 no. 33040 appears to have completed its turn and is ready to move off.

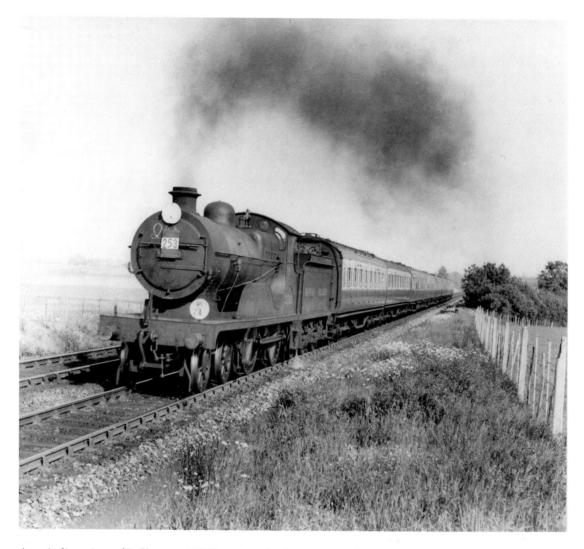

A main line view of L Class no. 31780 nearing its destination of Hastings.

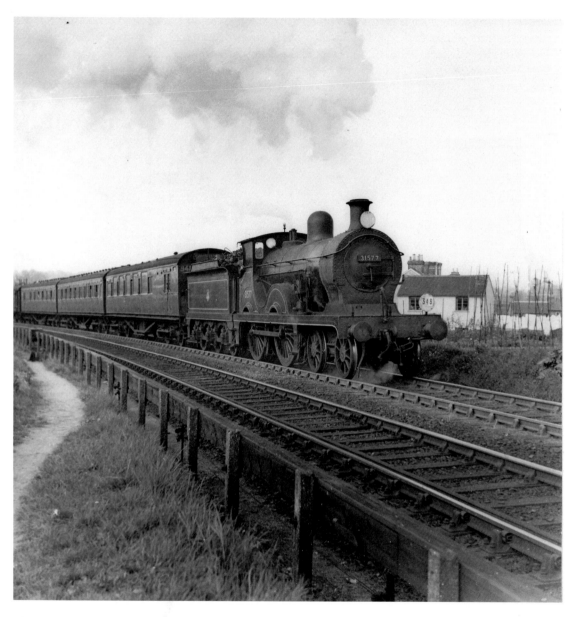

Photographed near Hastings is D Class 4–4–0 no. 31577, built in 1901 to a Wainwright design for the SECR.

Everyone knows about King Harold and the Battle of Hastings, but our friend who knows more about southern England than I do tells us that Hastings people will claim that television was invented there by local resident, John Logie Baird, and also that Hastings has a large fishing fleet, but no harbour and all the boats of the fleet have to be beached. Like many other south coast towns, the coming of the railways created a tourist industry and the town grew rapidly.

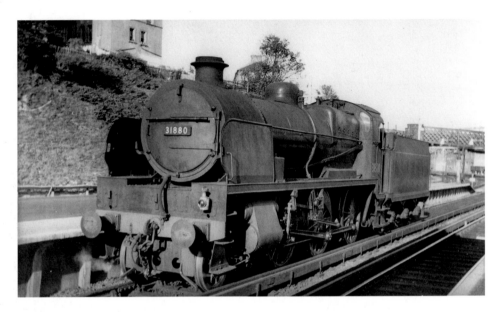

N1 no. 31880 running light engine at Hastings station, probably coming from the shed to pick up a train, perhaps to take holidaymakers back to London.

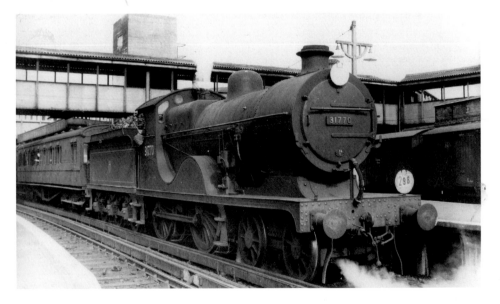

A station scene at Hastings as L Class no. 31770 prepares to depart for London via Tonbridge.

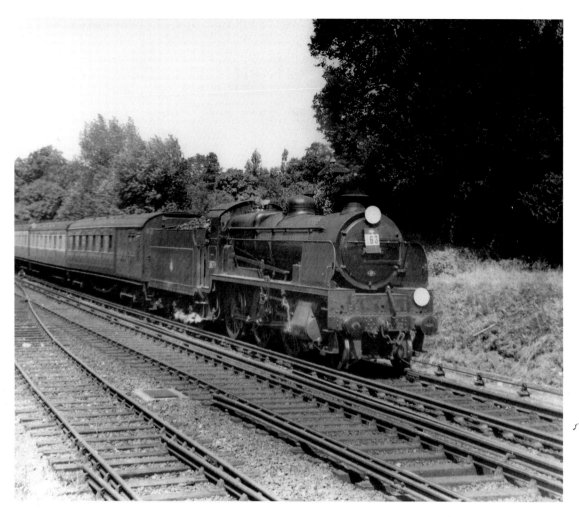

Nl 2–6–0 no. 31879 on its way to Hastings with no doubt many holidaymakers on board, all hoping that the summer sunshine would last.

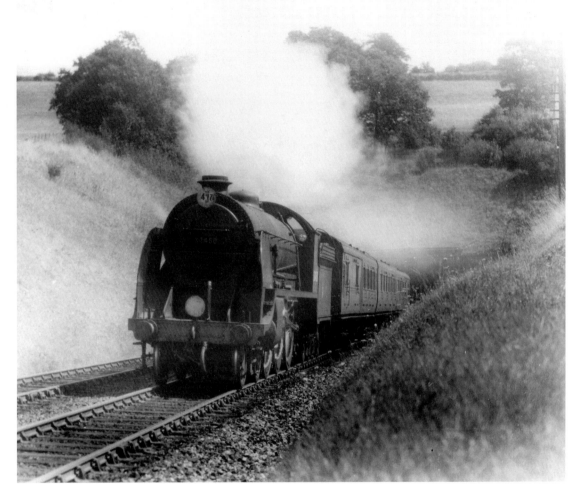

Leaving Ore Tunnel near Hastings is 'King Arthur' 4–6–0 no. 30450 *Sir Kay*.

We have left Hastings behind, also the sea views have disappeared and we have moved inland, through Winchelsea and Rye. Soon we shall be approaching Appledore but just before the station is the branch to Lydd.

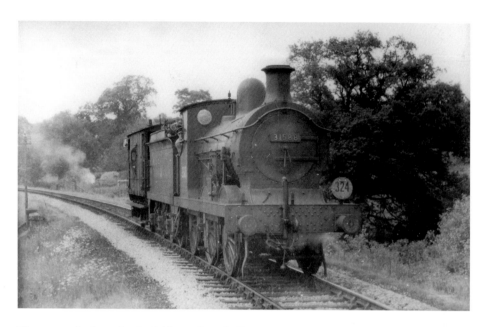

Photographed on the Lydd branch is C Class 0–6–0 no. 31588 with only a brake van behind the tender, suggesting that it is either going to pick up a freight train, or is going back after delivering goods to Lydd.

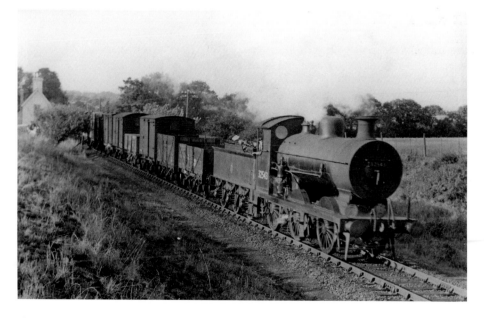

C2X Class 0–6–0 no. 32543 with a mixed freight, photographed on the Lydd branch.

The Lydd branch opened in 1881, built by the SECR to serve Dungeness and the Admiralty Sidings.

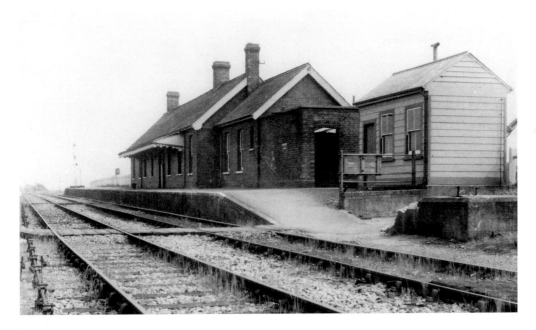

Lydd Town station photographed in 1960.

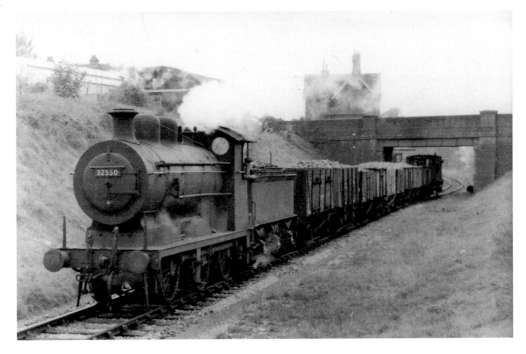

Coal for Lydd headed by C2X 0–6–0 no. 32550.

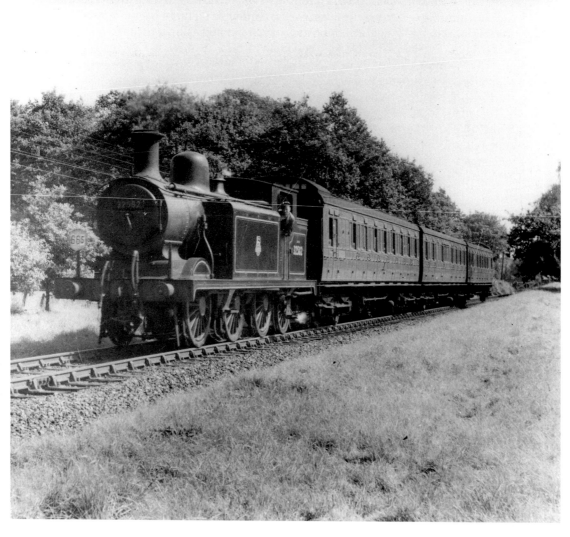

E4 0–6–2T no. 32582 with a three-coach passenger train on the Lydd branch.

The Lydd branch served Dungeness which of course is where the Romney, Hythe & Dymchurch Railway starts its journey along the coast to Hythe. Before I left the West Country, I looked up the history of this 15in gauge line. The idea of a 15in gauge line was the brainchild of two racing car drivers, Captain J.E.P. Howey, and Count Louis Zborowski. Regrettably the count was killed in a racing accident before plans had been finalised, so Captain Howey continued the dream alone. The site chosen between Romney and Hythe suited the miniature railway perfectly; it was level ground and uninhabited. Opened in 1927, the first train was hauled by *Hercules*. The line was taken over for war work in the Second World War and armoured trains with anti-aircraft guns mounted on them were to be seen trundling up and down the line. After the war, the line was reopened for public service in 1947 by none other than Laurel and Hardy of comedy film fame. The line is still serving the public, including a school run.

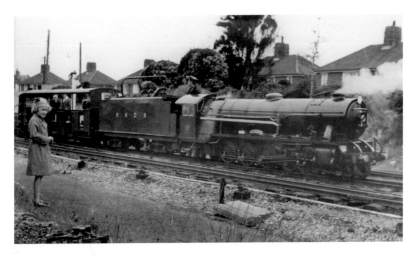

Watched by a little girl, *Hercules* is about to start another journey on the 14 miles of the Romney, Hythe & Dymchurch Railway.

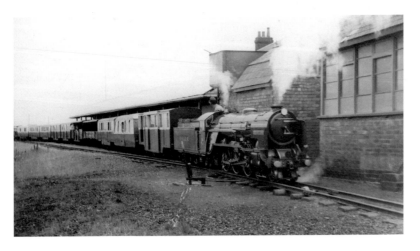

A long train of holidaymakers starts its journey behind a spotless loco on the Romney, Hythe & Dymchurch Railway.

Our train is speeding us to our next stop, Ashford. Again we were lucky enough to obtain permits to visit the works and shed, something our group is looking forward to. Our 'West Country' loco has the brakes on, and we take the curve leading into Ashford very slowly before finally coming to a halt in the station.

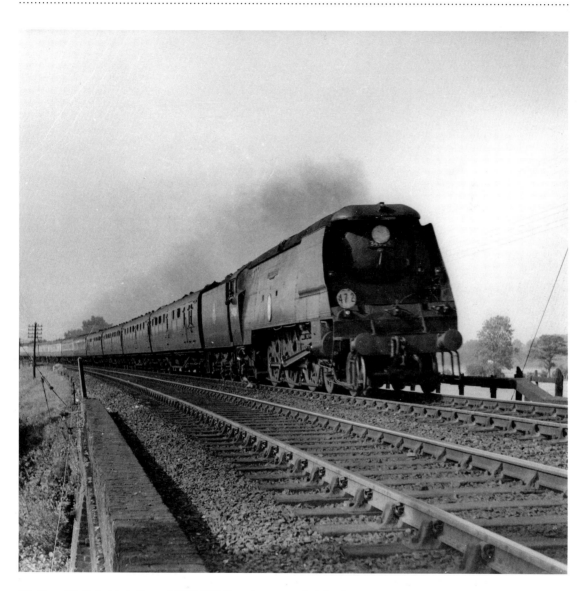

'Battle of Britain' 4–6–2 no. 34084 *253 Squadron* near Ashford.

Ashford, apart from having a large locomotive works and shed 73F, is a major junction. The line from Brighton which we have just arrived on is one of three main lines that arrive from the south – the others being the Folkestone and Dover lines. The other main line is from Canterbury, while going west from Ashford is a direct line to Tonbridge. The final junction is to Maidstone totalling five lines meeting in Ashford, a railway enthusiast's dream.

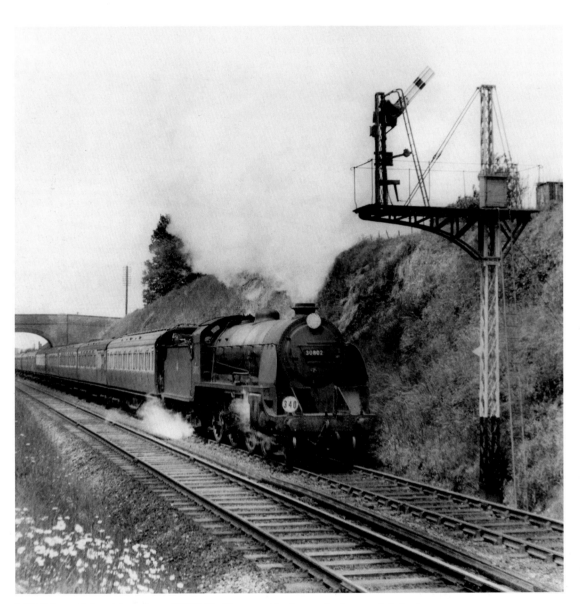

N15 'King Arthur' 4–6–0 no. 30802 *Sir Durnore* photographed near Ashford.

Showing our permits, we are again visiting a major works under the guidance of an experienced driver who is semi-retired and looks after parties of enthusiasts like us.

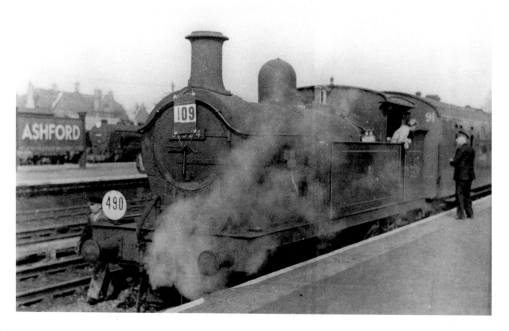

H Class 0–4–4T no. 31324, a Wainwright design for the SECR in 1904, is preparing to leave Ashford with a stopping train to Dover via Minster and Deal.

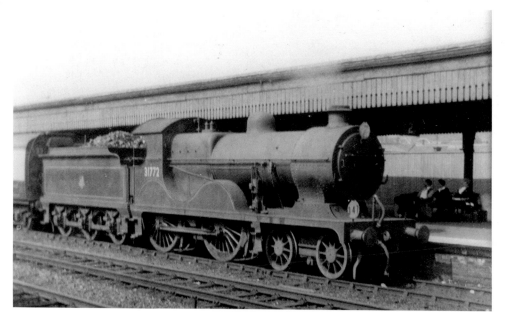

Another Dover-bound train at Ashford, headed by Class L no. 31772.

Ashford shed and works was built for the SECR in 1846. Cudworth was the first
Superintendent, and nearly 700 locos were built here. In 1899 the SECR amalgamated with
the London Central and District Railway – thank goodness our guide is very informative!
On the Southern Railway, he talks about the engines we are seeing, what goes where
and what it does.

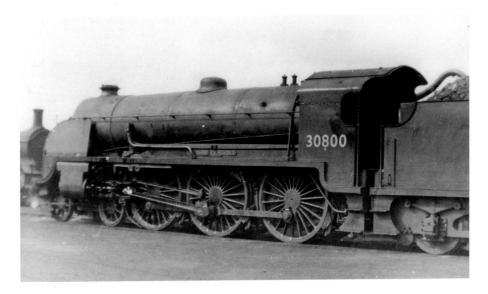

In the yard at Ashford shed is 'King Arthur' 4–6–0 no. 30800 *Sir Meleaus de Lile*.

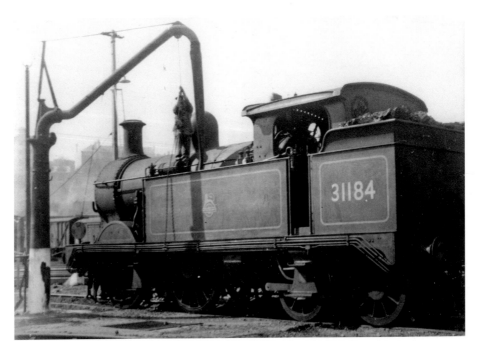

Taking a drink in the shed yard is H Class 0–4–4T no. 31184.

We have all taken many photographs, and recorded everything we have seen in the works. We have said our thanks to our guide, and now we are being escorted around the shed by a young cleaner who has been detailed to look after us. The time is fast approaching when we must make our way back to Ashford station to continue our journey to Folkestone.

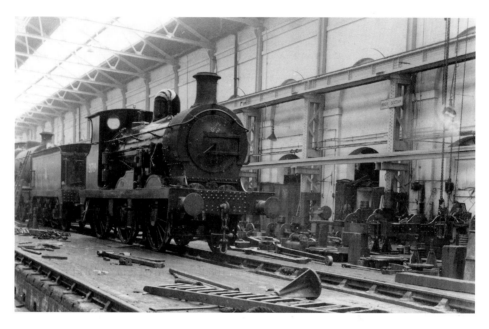

Inside Ashford shed is C Class no. 31719.

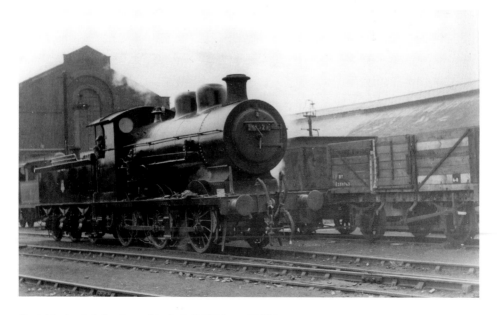

Outside in Ashford yard is 0–6–0 C2X no. 32523.

Two final pictures at Ashford shed. We will get another view of the shed from our carriage window as the yard is on the east side of the Folkestone line south of the station.

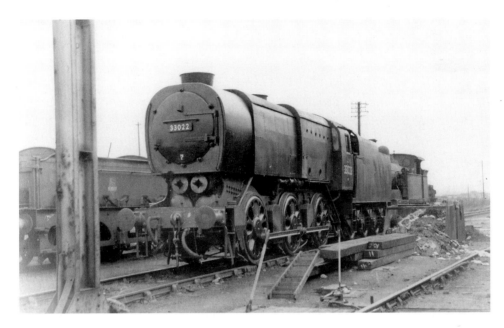

Q1 0–6–0 no. 33022, photographed in the yard at Ashford.

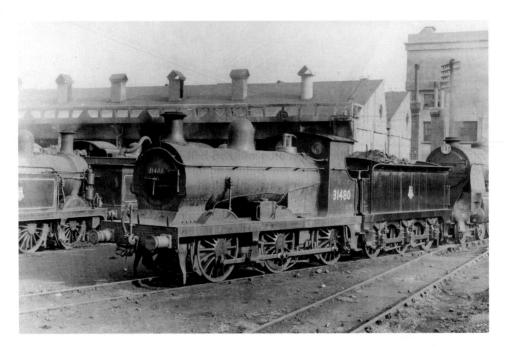

C Class 0–6–0 no. 31480, another Southern engine that has led a long life. Brand new in 1900, this picture was taken in 1953 at Ashford.

Time for some more refreshments and a rest on the cushions as there is not much to see in the way of railway interest. There is, however, lovely countryside to look at, and in bright sunshine we can enjoy a sandwich and a cup of tea.

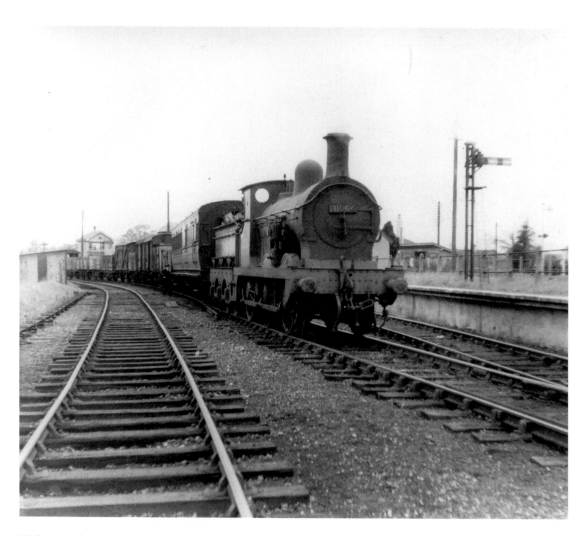

With a very mixed freight train is O1 Class no. 31064 near Ashford.

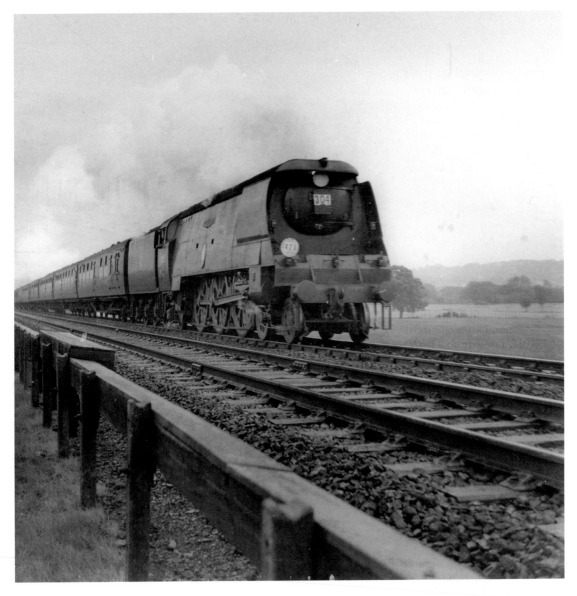

Having left Ashford behind, 'Battle of Britain' 4–6–2 no. 34083 *605 Squadron* is heading for Dover.

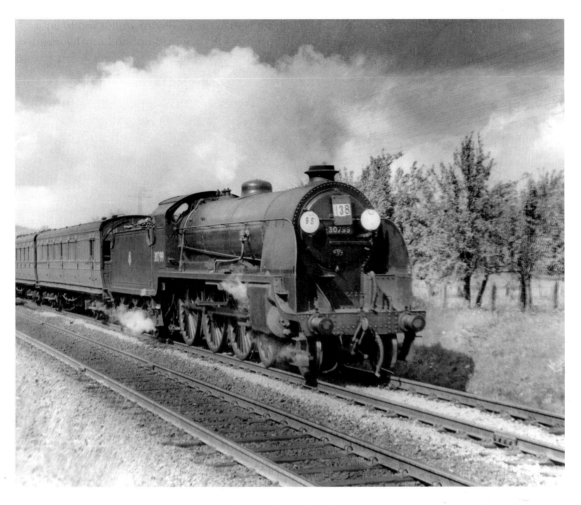

'King Arthur' 4–6–0 no. 30799 *Sir Ironside* near Smeeth with a Dover train. It seems to have the wrong headcode as according to the record books it should be going to Reading or Portsmouth.

The South Eastern & Chatham Railway ran a Paris service from Victoria starting at 11 a.m. for many years. The Southern Railway continued this service in 1923 at the grouping, and in 1929 it was decided to make the service more exclusive – it was to become first class only and to use Pullman cars. There was even a special ferryboat built, the *Canterbury*. The train was to be called the 'Golden Arrow' and the principal motive power was supplied by the 'Lord Nelson' class. Service was suspended during the Second World War and was not reinstated until April 1946 when the departure time was also changed to 10 a.m. Also, the motive power changed to using the new Bulleids. Another change took place in 1952 when the start time from Victoria was altered to 2 p.m.

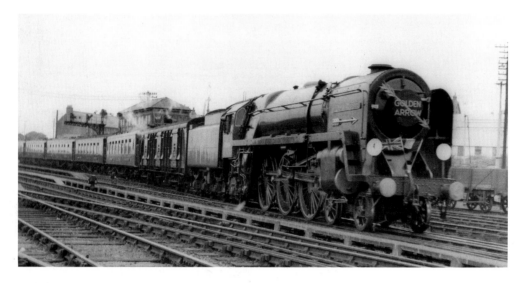

'Britannia' no. 70004 *William Shakespeare* running through Folkestone with the 'Golden Arrow' en route to Dover.

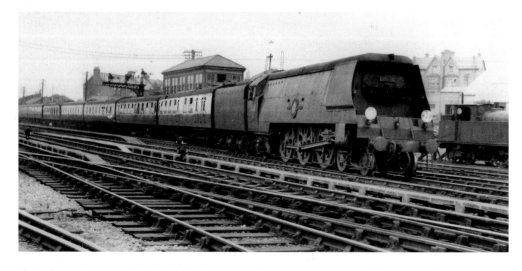

'Merchant Navy' no. 35030 *Elder Dempster Lines* also departing Folkestone, with a train for Dover.

'Battle of Britain'
no. 34078 *222 Squadron*
at Folkestone.

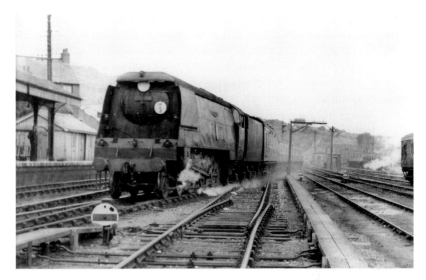

Approaching
Folkestone is 'King
Arthur' no. 30769
Sir Balan.

This time it is a
'West Country' that
is photographed at
Folkestone, namely
no. 34092 *City of Wells*.

Trains routed via Folkestone to the French coast had an easy descent to the harbour for passengers to detrain and join the ferry to be taken across the Channel. However, it was a different matter for the return journey. The carriages would be at Folkestone Harbour waiting for passengers alighting from the ferry with two or three tank locos. The train would then be hauled to Folkestone Junction up a steep incline, where a main line loco would be waiting to back on to the rear end of this train (which of course now became the front end), ready to speed the passengers to London.

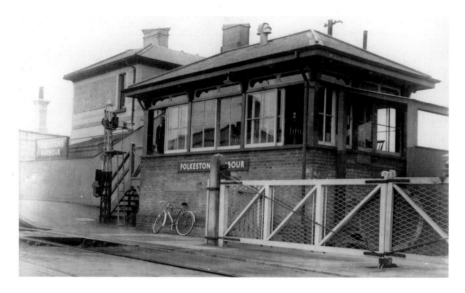

Controlling all the rail traffic to the harbour is Folkestone Harbour signal-box. This photograph was taken in 1951.

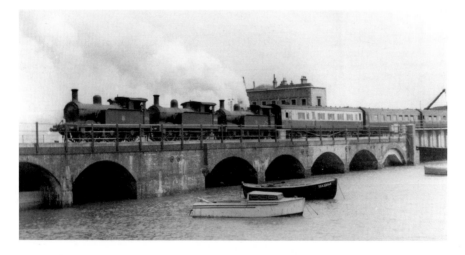

The steepest gradient on the Southern Railway system at 1 in 30 was from Folkestone Harbour to the main line, a sight enjoyed by railway enthusiasts to see three locos working hard. Here nos 31154, 31128 and 31152, all of the Rl 0–6–0T class, are hard at it in 1951.

Folkestone was fishing village in Roman times, but it became a town during the Tudor period. In 1809 the harbour was built which the South Eastern Railway purchased in 1843 when the owners went bankrupt. The railway subsequently built the Harbour line. The SER also built an impressive viaduct on the Folkestone–Dover line just to the east of Folkestone. The Foord Viaduct built in 1843 is 100ft high and has nineteen arches.

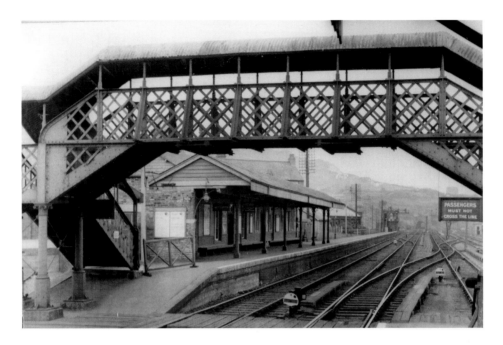

Folkestone Junction station was opened in the 1850s by the SECR.

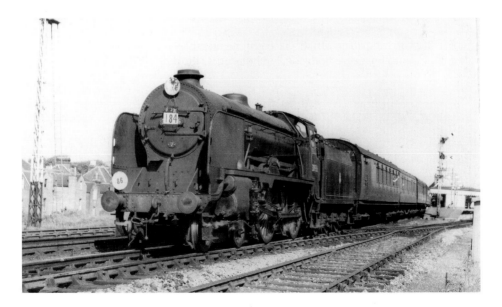

'Schools' 4–4–0 no. 30936 *Cranleigh* at Folkestone with a Dover train.

'The Man of Kent' express was short lived, originating at Charing Cross. It made a fairly fast run to Folkestone and Dover. It was in 1953 that the name was given to the 4.15 p.m. departure from Charing Cross, arriving in Folkestone at 5.35 p.m. The 'Schools' class were used originally, but later the 'Battle of Britain' class were utilised. In 1961 electric traction took over and all trains were now timed the same and its distinctive title was dropped.

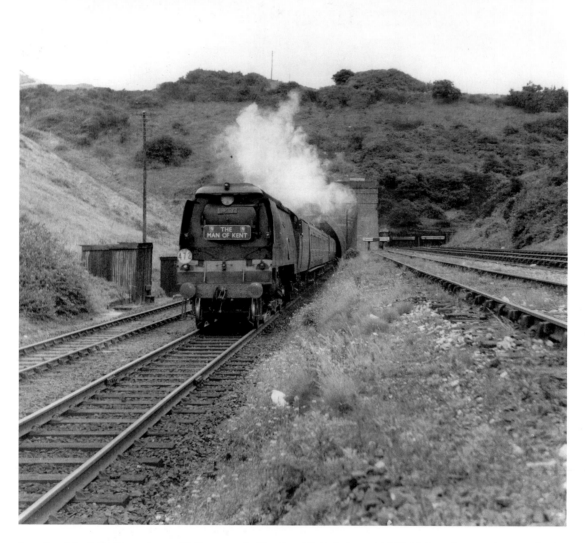

Leaving Martello Tunnel near Folkestone is 'Battle of Britain' no. 34076 *41 Squadron* in charge of 'The Man of Kent'.

We are running by the sea again, looking gloriously blue in the summer sunshine, but not for long though, as our train will soon be into Abbotscliffe Tunnel which is over a mile long. When we emerge into daylight again it will be the White Cliffs on our left as we slow for our stop in Dover. However, before we stop we will go through another short tunnel, the Shakespeare Tunnel, built in 1844 for the South Eastern Railway by William Cubitt.

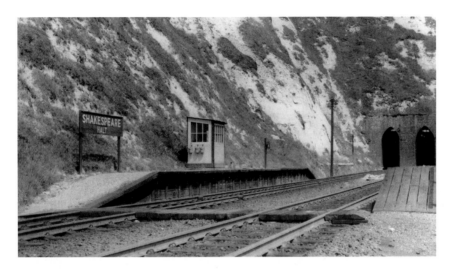

The White Cliffs of Dover, towering over the tiny Shakespeare Cliff Halt station in this summer view. It looks as though it's not a station to be waiting for a train on a stormy winter's day, or worse still, night. It was opened in June 1913.

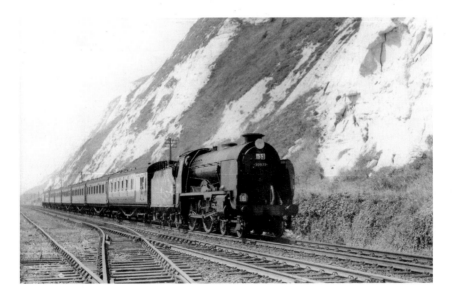

Looking a little more friendly in the summer sun is this view of 'Schools' 4–4–0 no. 30939 *Leatherhead*. The Chairman of Governors at Leatherhead College during the 1950s and early '60s was Viscount Montgomery of Alamein.

When looking at a Dover reference book detailing when a particular station opened, and by which company, it is surprising that there are references to fifteen stations; there was a lot of railway activity in Dover. According to archaeologists there was human presence here in the Stone Age, with many finds to prove this. As Dover is the nearest point in Britain to mainland Europe, it is not surprising that there has been a ferry and naval presence here for hundreds of years, and indeed it is still the major ferry port to Europe. With the arrival of the railway in 1843, travel to Europe really took off, and Dover became the huge port that it is today with frequent trains to London.

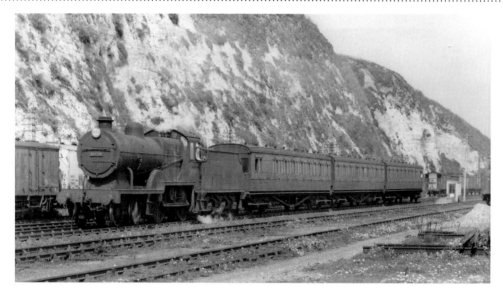

Leaving Dover and running along the White Cliffs is Class Ll no. 31759.

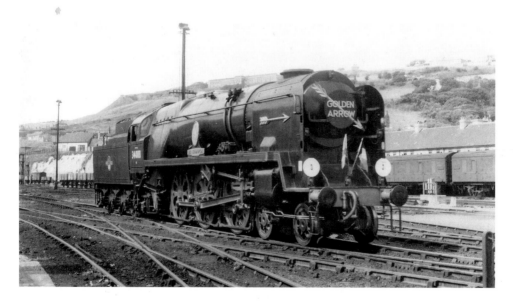

Making its way to Dover shed is 'Battle of Britain' no. 34088 *213 Squadron* having arrived with the 'Golden Arrow'.

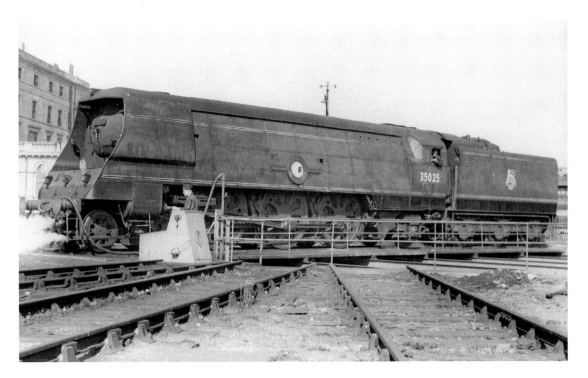

On the turntable at Dover shed is 'Merchant Navy' no. 35025 *Brocklebank Line*.

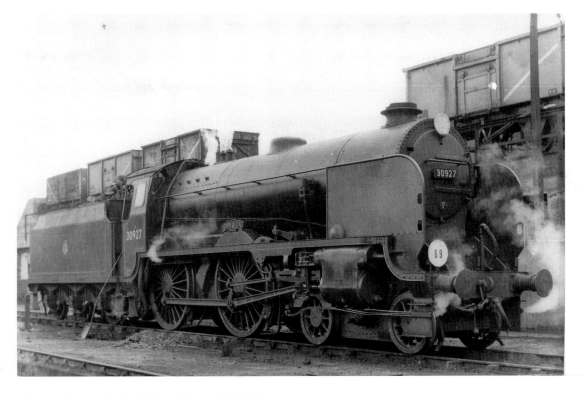

Also on Dover shed is 'Schools' no. 30927 *Clifton*.

We did not leave our train at Dover when we came to a halt, except for a quick visit to the refreshment rooms. Dover Priory is the main station, but there are many lines to the harbour area, and main line expresses could be routed to almost pull up by the cross-channel ferries.

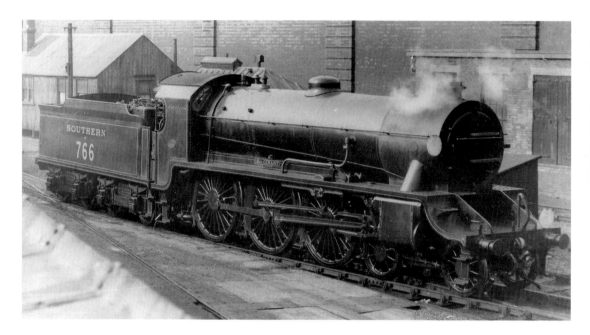

With its tender very low on coal, this is a view of a 'King Arthur' in Southern days. No. 766 *Sir Geraint* arrives in Dover shed after working a train from London Bridge.

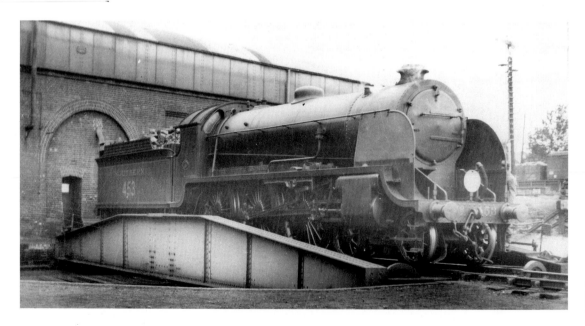

Another view in Southern days at Dover shed. This time with plenty of coal in the tender and being turned, no. 453 *King Arthur* himself is being made ready to work a train back to London.

Our train is on the move again after a short stop. We are now on our way to Ramsgate and Margate. Leaving Dover, we go through Charlton Tunnel and then take the right fork at Buckland Junction, then Kearsney Junction, and we are heading for Ramsgate.

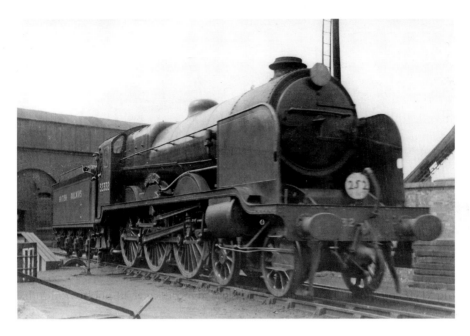

Nl5X 'Remembrance' class 4–6–0 no. 32332 *Stroudley* named after the London, Brighton & South Coast Railway engineer (between 1870 and 1889), William Stroudley. It is photographed at Dover shed ready for its next duty in 1949.

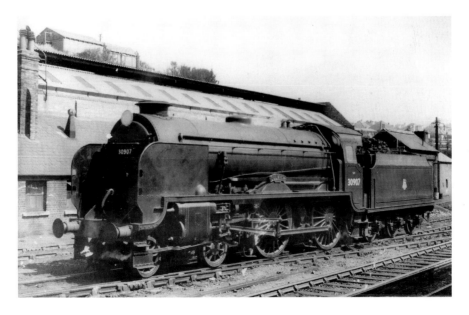

'Schools' no. 30907 *Dulwich* also ready for duty at Dover.

Leaving Dover behind, we have a fair distance to go before we get to Ramsgate. Now is the time to enjoy the food and drink we bought in the refreshment rooms at Dover.

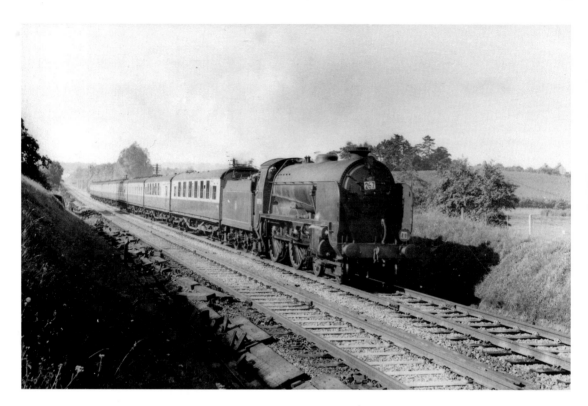

'Schools' 4–4–0 no. 30926 *Repton*, photographed in the summer sunshine of 1955 near Deal. The train is for Ramsgate and Margate, no doubt full of happy holidaymakers hoping for a week in the sun.

We have had a relaxing half-hour or so and a bite to eat before we see anything else. At Minster we shall turn east for a short while to Ramsgate, and then head north to Broadstairs and Margate before turning west towards London.

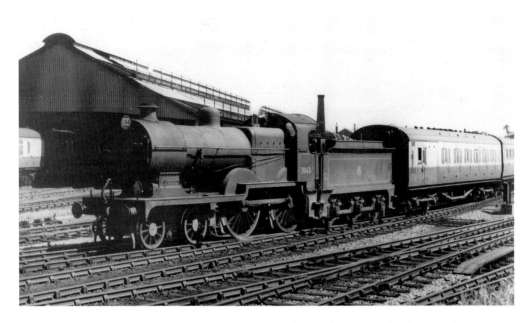

Dl 'Class' 4–4–0 no. 31145 arriving in Ramsgate with another train of holidaymakers.

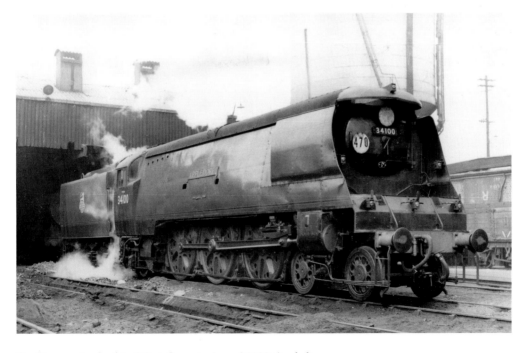

On Ramsgate shed is 'West Country' no. 34100 *Appledore*.

We are enjoying the views from the carriage window, but there's not a lot to photograph, as we are through Broadstairs which is not a big station and will soon be approaching Margate.

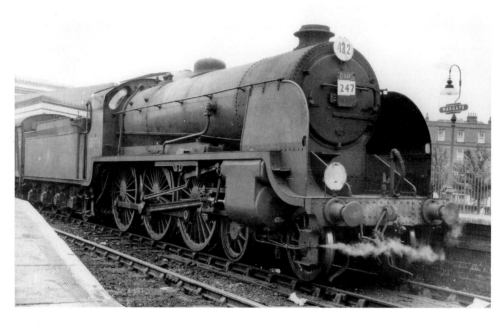

'King Arthur' no. 30776 *Sir Galagars* arrived in Margate, with more hopeful sun seekers, although the weather does not look promising in this photograph.

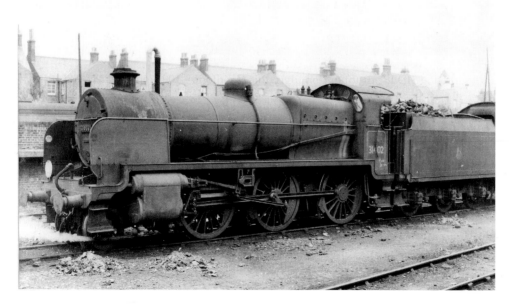

N Class 2–6–0 no. 31402 photographed at Margate.

Turning west towards London, we pass through Westgate-on-Sea, and then Birchington-on-Sea, and we run in an almost straight line for many miles before arriving at Whitstable where we make a brief stop. There is a branch on our left to Canterbury.

Westgate-on-Sea station opened in 1871 for the London, Chatham & Dover Railway. A close neighbour to Margate, it is a favourite day out for Londoners.

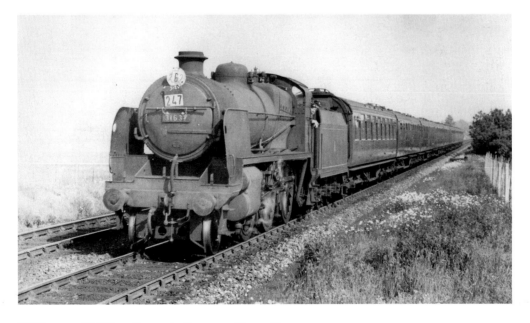

U Class no. 31637 on the main line near Herne Bay.

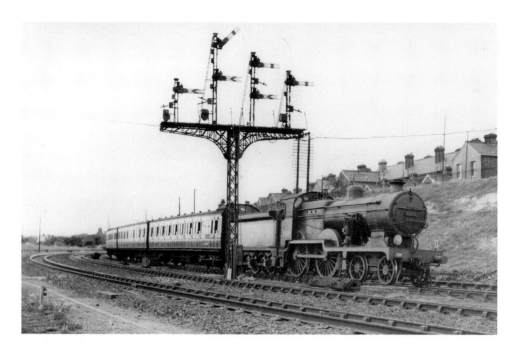

Class Dl 4–4–0 no. 31727 near Whitstable. It started life in 1901 as a D Class built by Wainwright, but in 1921 Maunsell rebuilt a number of the class with superheating and detail differences.

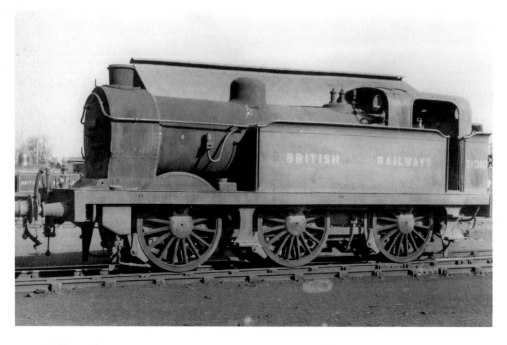

0–6–0T Class Rl no. 31010. This is another loco that was built at the end of the nineteenth century and it had a long life as an R Class, until it was rebuilt in 1938 by Urie with a short chimney for working the Whitstable branch from Canterbury, where it was photographed in 1953.

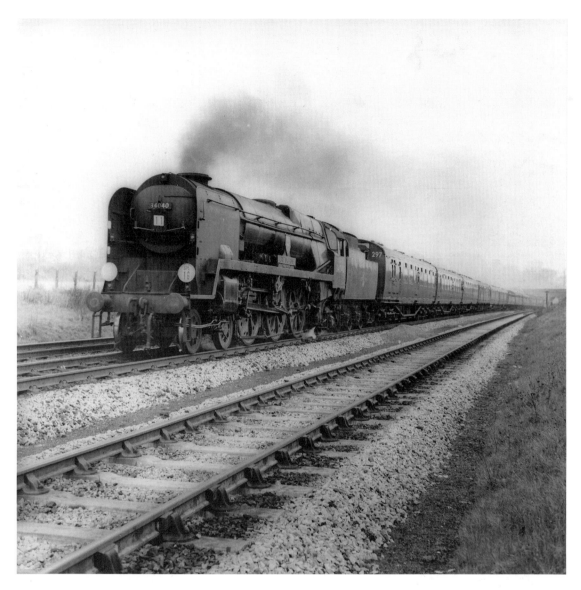

'West Country' 4–6–2 no. 34040 *Crewkerne* near Faversham.

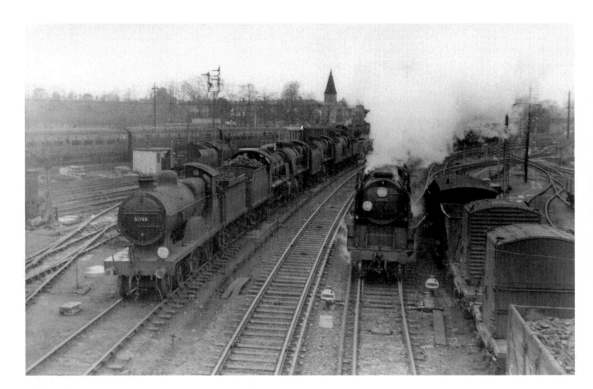

L Class 4–4–0 no. 31768 at the front of a line-up of locos at Faversham. Passing on the main line is 'West Country' no. 34013 *Okehampton*.

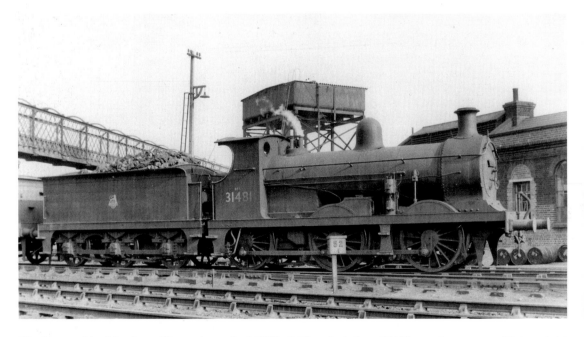

Nicely posed in this view of Faversham shed 73E is C Class 0–6–0 no. 31481, another veteran Wainwright from 1900.

Still making our way back to London, our train is now approaching Sittingbourne, where there is a junction heading towards the Thames and the dockyards at Sheerness. On from Sittingbourne, our train is now through Newington.

'King Arthur' 4–6–0 no. 30797 *Sir Blamor de Ganis*, picking up passengers at Sittingbourne on the main line to Margate.

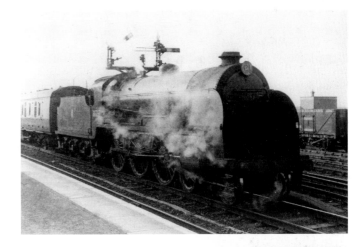

N Class no. 31408 near Newington with a freight train.

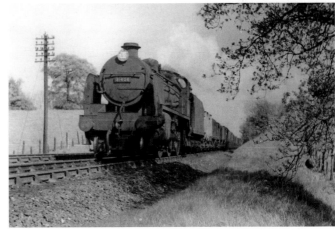

Another N Class, no. 31411, also heading a freight train near Newington.

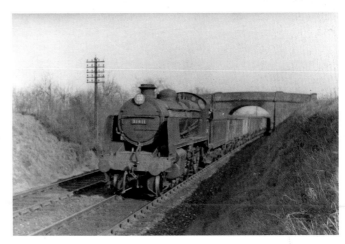

After Newington comes Gillingham, where there are several small branch lines to the dock areas, including Chatham.

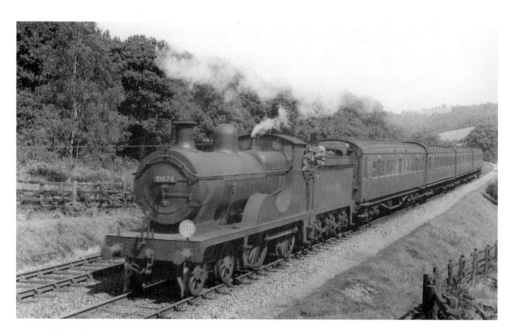

No. 31176, an E Class 4–4–0 of Wainwright design for the SECR dating from 1905, photographed in summer sunshine near Gillingham in 1952.

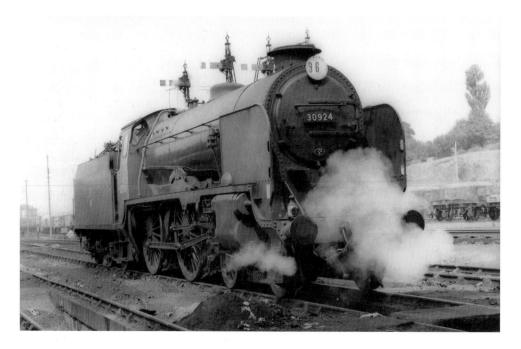

'Schools' 4–4–0 no. 30924 *Haileybury* on Gillingham shed 73D.

Traffic can be heavy on these lines with so many dock areas, so we keep watch at the windows as we go through Strood. We are still travelling at about 60mph at Sole Street and then Fawkham, where there is another junction to the very busy port of Gravesend. The station was built in 1849 for the South Eastern Railway. It is a listed building with a colonnaded frontage. The town pier was built in 1884 to accommodate the London, Tilbury & Southend Railway, which wanted to run passenger steamers to Gravesend.

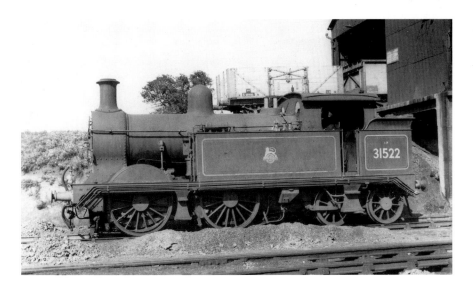

H Class 0–4–4T no. 31522, built in 1904. It was rebuilt again in 1949 and fitted for push and pull. This view is in the yard of Gillingham shed.

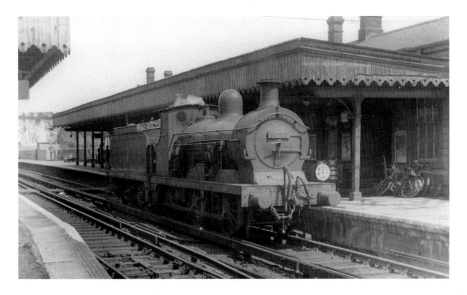

Strood is the setting for this view of Class C 0–6–0 no. 31720. This is another long-lived loco; born in 1900, it was still going strong when photographed in July 1957.

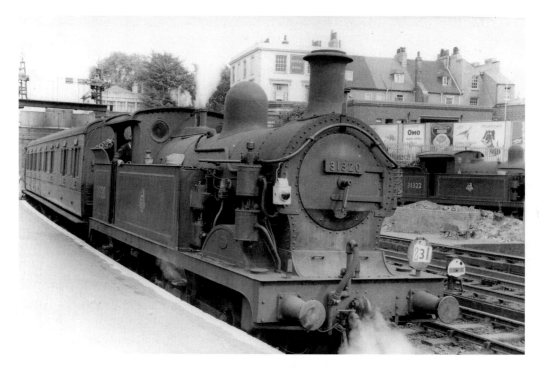

H Class 0–4–4T no. 31320 has just arrived at Gravesend with a short passenger train.

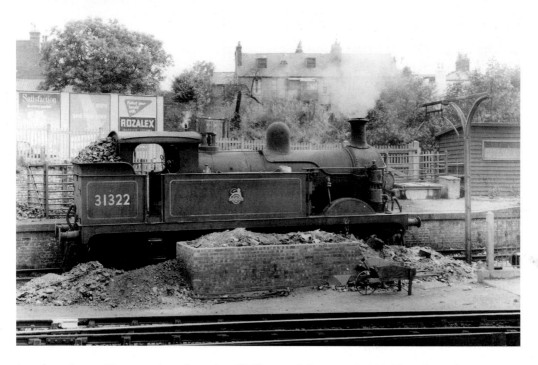

Another view at Gravesend, and another H Class tank loco, no. 31322. This class of engine was another of Wainwright's creations for the SECR in 1904.

We shall soon be approaching Swanley, where on our left is a junction heading south to Otford through St Mary Cray. We shall be slowing for the busy junction of Chislehurst and into the last few miles before arrival at London Bridge station.

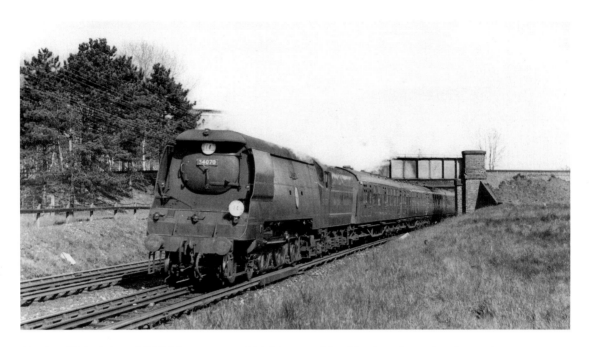

'Battle of Britain' no. 34070 *Manston* near Chislehurst with a Hastings-bound train.

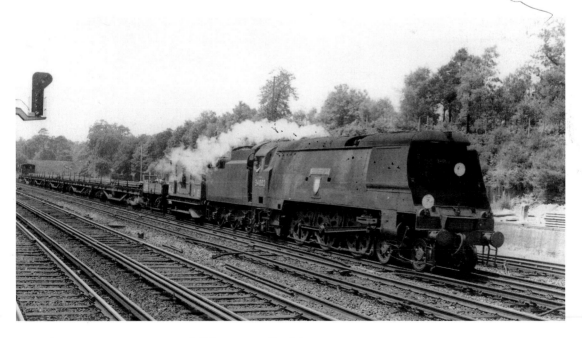

'West Country' 4–6–2 no. 34002 *Salisbury* near Chislehurst.

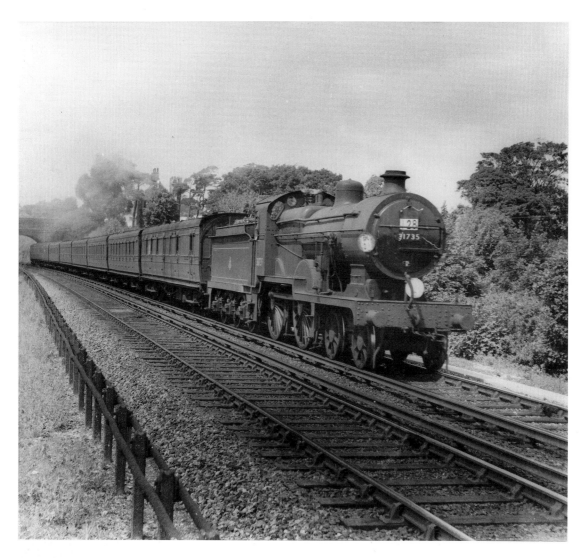

Another view near Chislehurst is of D1 4–4–0 no. 31735 in glorious summer sunshine delivering more holidaymakers to Kent beaches, this time to Ramsgate.

While we will be going to London Bridge, the junction at Chislehurst will also see trains going to Victoria via Bromley.

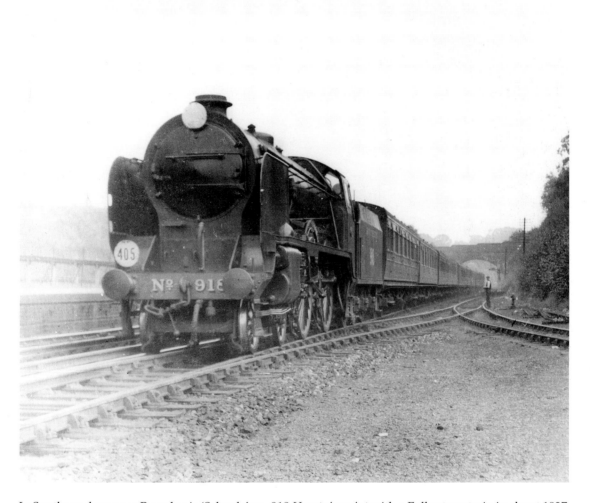

In Southern days near Bromley is 'Schools' no. 918 *Hurstpierpoint* with a Folkestone train in about 1937.

Still keeping up a steady speed, it seems to us amateurs that we are cruising at around 60mph as we approach Hither Green 73C. We are all in the corridor looking to see what's on shed, as the yards are clearly visible from the main line.

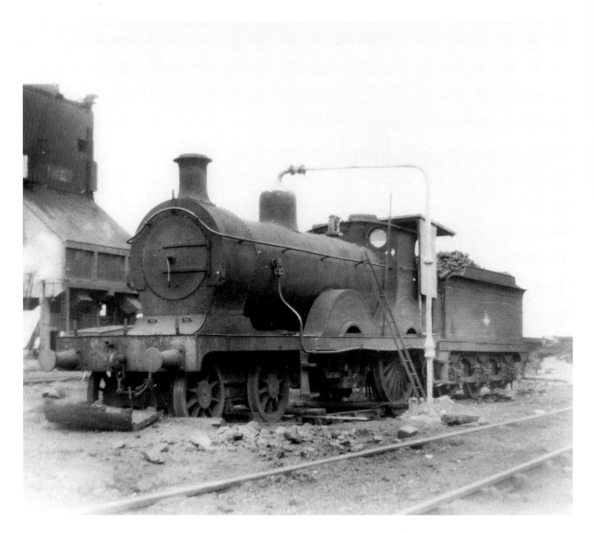

Hither Green shed 73C is where D Class 4–4–0 no. 31501 was to be found in use supplying hot water to the shed, a sad end to a loco which had performed on express trains for the SECR from 1901.

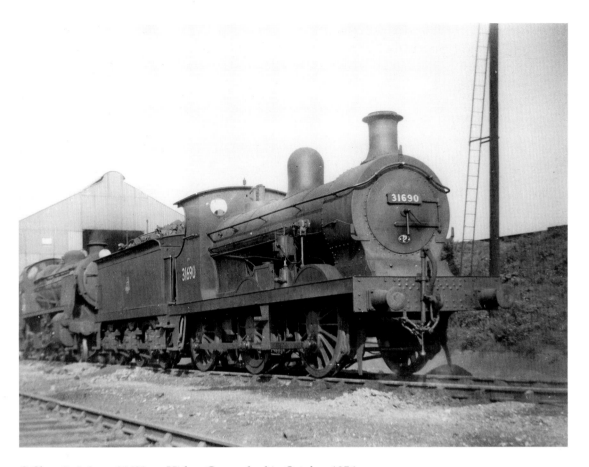

C Class 0–6–0 no. 31690 on Hither Green shed in October 1956.

Our train is beginning to slow down now, as we are well into the suburbs of London, passing through New Cross Gate then Bricklayers' Arms. Now we are moving slowly on the final approach to London Bridge station.

At New Cross Gate in Southern days is Class B4 no. 2057.

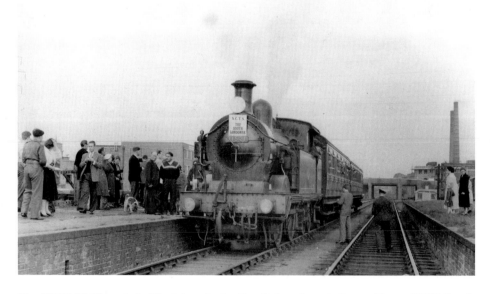

No. 31521 H Class 0–4–4T pictured at a South London station with an SCTS South Londoner railtour in the 1950s.

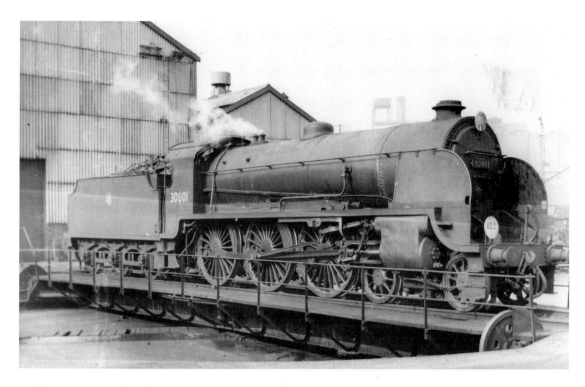

A 'King Arthur' at Bricklayers' Arms, no. 30801 *Sir Meleaus de Lile*.

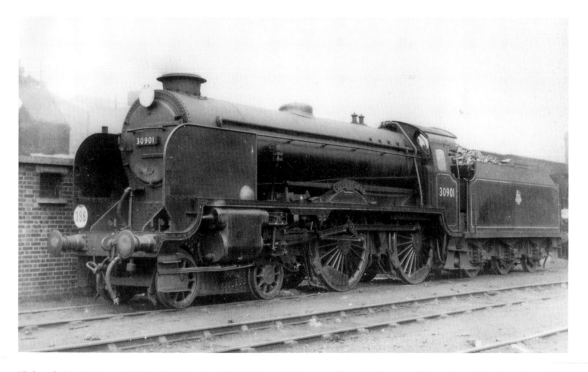

'Schools' 4–4–0 no. 30901 *Winchester* at Bricklayers' Arms, all coaled up and bearing a headcode stating that it's going to head a train from London Bridge to Folkestone.

We have arrived at London Bridge station after another part of our Southern journey.
London Bridge station is one of the oldest termini in London, built in 1836 for the London &
Greenwich Railway.

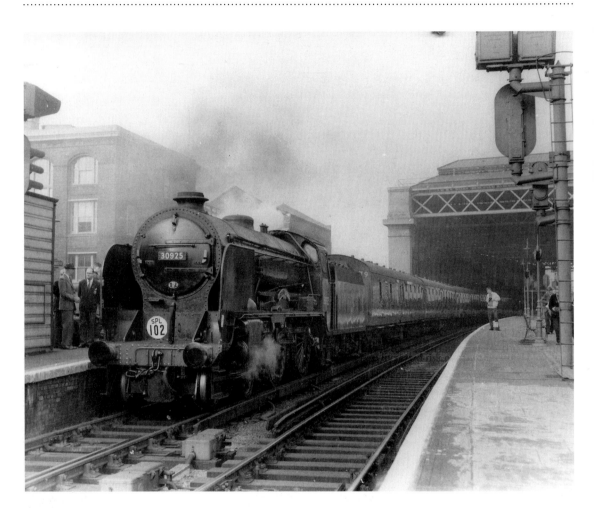

London Bridge was a terminus not visited by trainspotters and enthusiasts as much as Waterloo and
Victoria, but it was still an important station with trains departing for the Kent seaside resorts. The
platforms were frequently packed with holidaymakers with suitcases bulging, kiddies with buckets
and spades, and a British determination that they would enjoy themselves no matter what the weather
had in store. Photographed at London Bridge with a seaside special is 'Schools' no. 30925 *Cheltenham*,
a college which prides itself on the fact that fourteen of its pupils won the Victoria Cross.

Trains carrying holidaymakers from the north, especially the industrial areas of Lancashire and Yorkshire, could stay on the same train all the way to the south coast resorts such as Eastbourne and St Leonards. Their trains would come south on the main Midland route to Willesden, where they would leave the Midland line and work through the London suburbs to Addison Road, where the motive power would be changed from a Midland engine to a Southern. Freight trains heading south would also go through the same exchange.

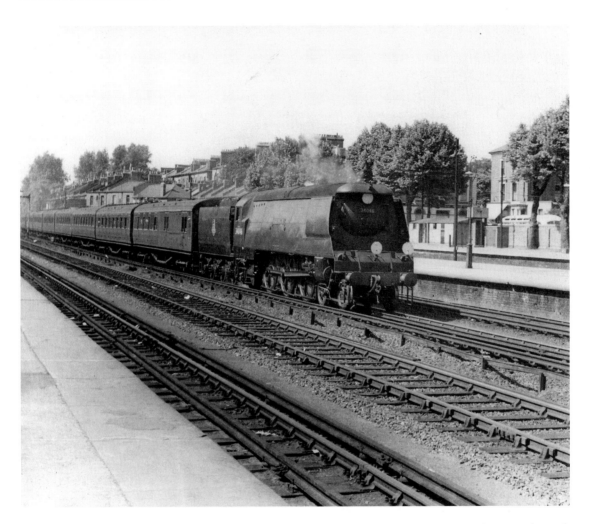

For trains destined for Kent from the north, the route from Willesden to the south went through Kensington Addison Road. Here, 'West Country' no. 34046 *Braunton* heads a train that has come from the Midlands via the west London line.

Three views at Kensington Addison Road.

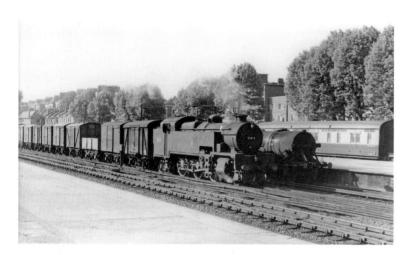

W Class 2–6–4T no. 31913 working a transfer freight through Kensington. Designed in 1931 by Maunsell, these locos weighed in at a hefty 91 tons.

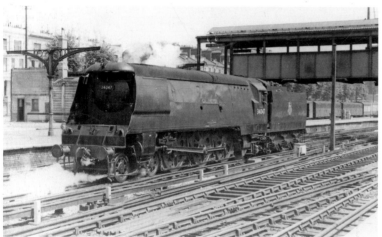

Working light engine from Stewarts Lane, 'West Country' no. 34047 *Callington* will pick up a train from the Midlands exchange point and head back through Addison Road.

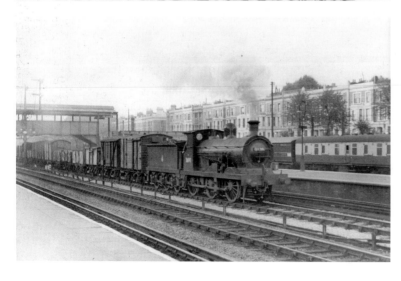

Another transfer freight headed by C Class 0–6–0 no. 31690.

One of our fellow travellers, an expert on the Southern, has offered to talk us through the journey from London Bridge to St Leonards. It should prove an interesting diversion, so we settle down to listen.

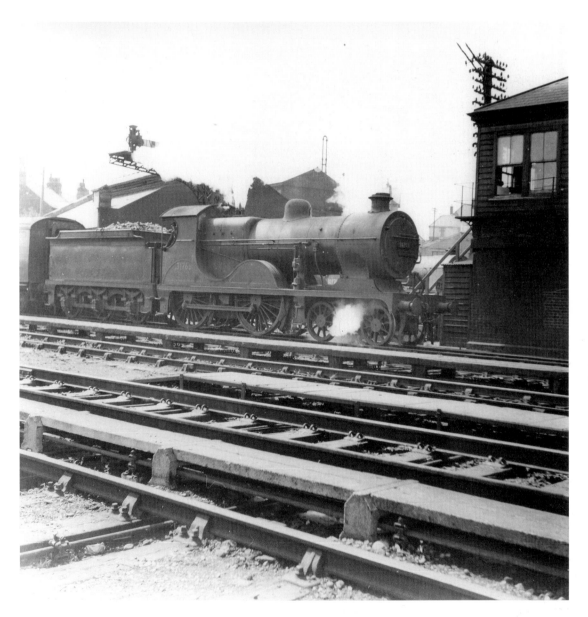

L Class 4–4–0 no. 31766 at New Cross in the suburbs of London.

Trains from the north via Addison Road join the main line from London Bridge near New Cross. If you look at a railway map, you can see that lines go direct to almost all of the south coast resorts. I have asked our expert to take us to St Leonards via Hither Green and Chislehurst.

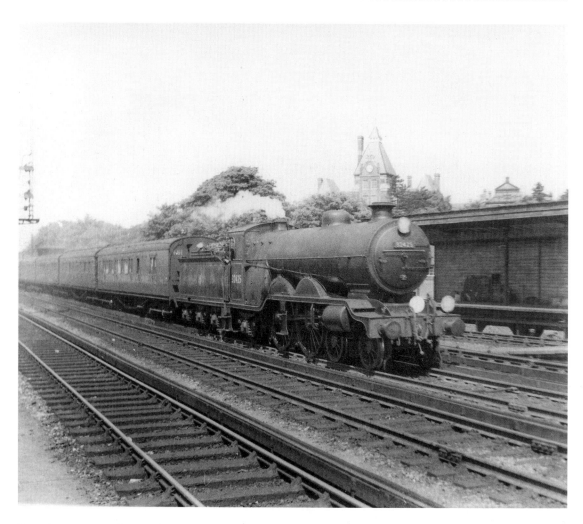

Running into London with a train bound for the Midlands is Class H2 4–4–2 no. 32425 *Trevose Head*, one of the Marsh Atlantics, built in 1911 for the London, Brighton & South Coast Railway.

Hither Green shed 73C is the location of these three views from Southern days to British Railways.

...

Southern 4–4–0 no. 2063 *Pretoria*.

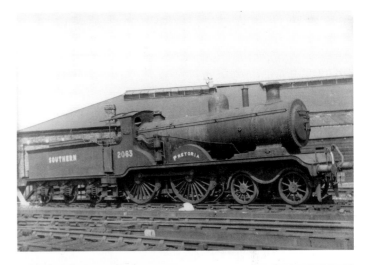

H Class 0–4–4T no. 31500 dating from 1904 and still working fifty years later in 1954.

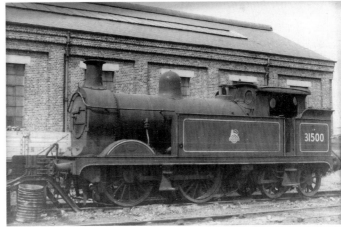

C Class 0–6–0 no. 31722 and companion N Class 2–6–0 no. 31823 in the yard at Hither Green.

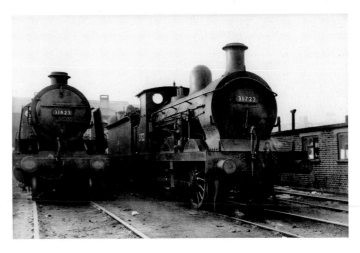

After Hither Green it is a fairly straight route through Grove Park, where there is a short branch to Bromley North, on through Chislehurst and then Petts Wood.

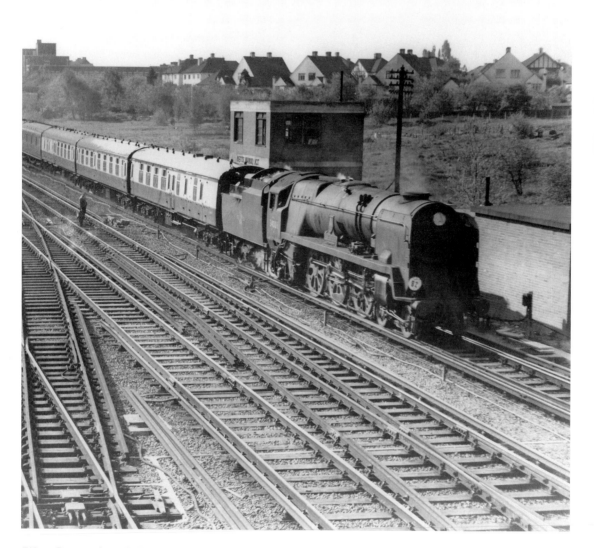

'West Country' no. 34001 *Exeter* near Petts Wood.

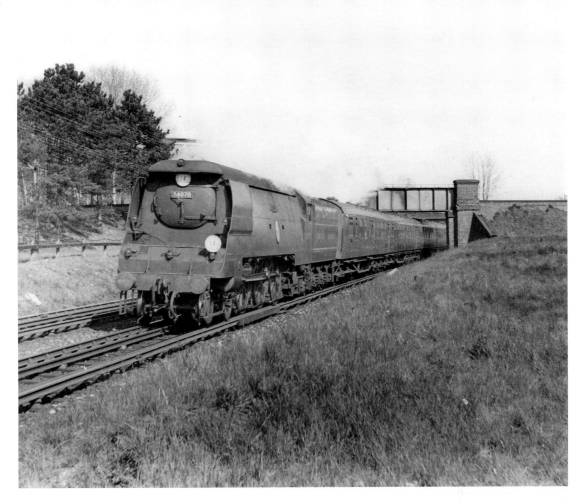

Another main line view of an express to the south coast, 'Battle of Britain' no. 34070 *Manston*, near Orpington. There is a steepish climb from Orpington to Knockholt, so speed drops a bit, but then picks up to about 70mph again.

Two more stations that will be passed at a steady speed are Chelsfield and Knockholt.

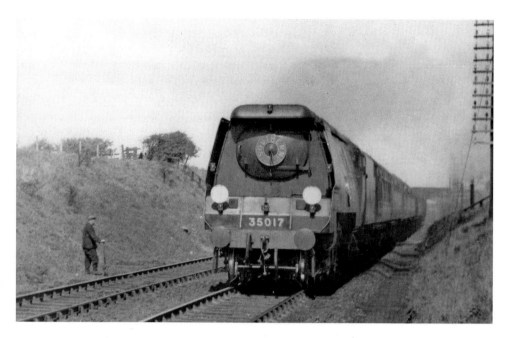

Still with its Southern Railway roundel on the smokebox, 'Merchant Navy' no. 35017 *Belgian Marine* was photographed near Chelsfield.

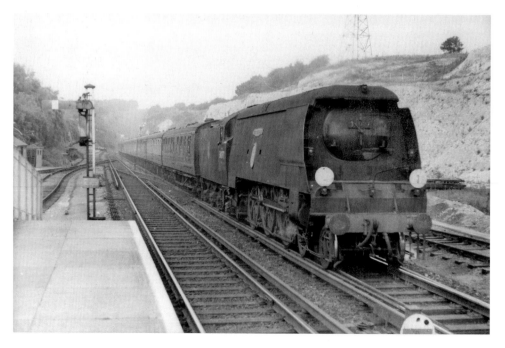

Approaching Knockholt is 'Battle of Britain' no. 34077 *603 Squadron*.

The next station we go through is Sevenoaks. No doubt there were seven trees after which the town was named, but as far as the railway enthusiasts are concerned, the Eynsford Viaduct is the main point of interest, built in 1862 by the Sevenoaks Railway, which in turn became the SER. The viaduct is 100ft high on nine red-brick arches, and has been likened to a Roman aqueduct.

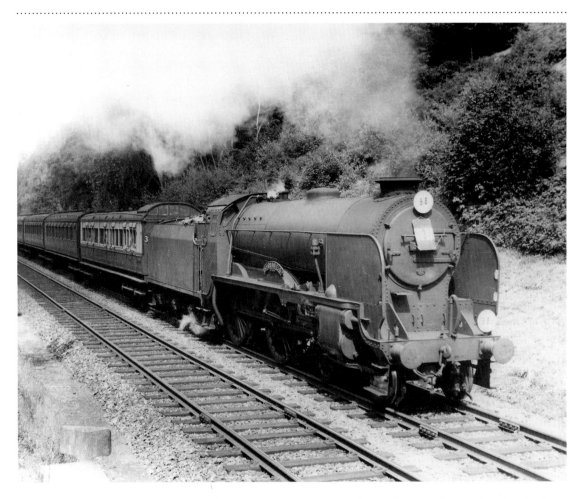

Approaching Sevenoaks Tunnel is 'Schools' 4–4–0 no. 30938 *St Olaves*. The tunnel is nearly 1½ miles long.

A good vantage point to photograph trains is Hildenborough, only 2½ miles from Tonbridge, but in a country setting, and with locos not going at any great speed.

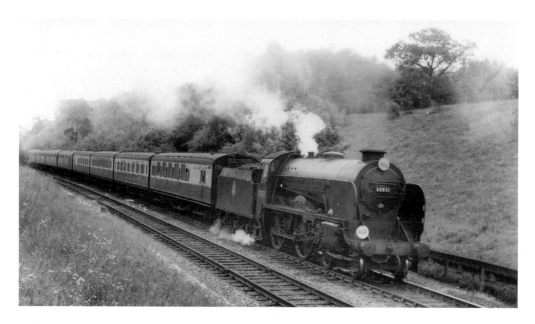

Making its way to the south coast is 'Schools' 4–4–0 no. 30921 *Shrewsbury*, photographed near Hildenborough.

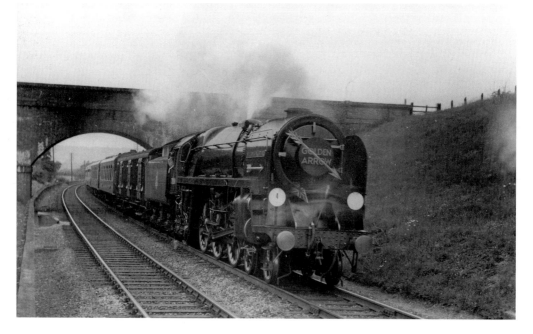

The 'Golden Arrow' on its way to Dover, headed by 'Britannia' 4–6–2 no. 70004 *William Shakespeare*. This view was also taken near Hildenborough in May 1953.

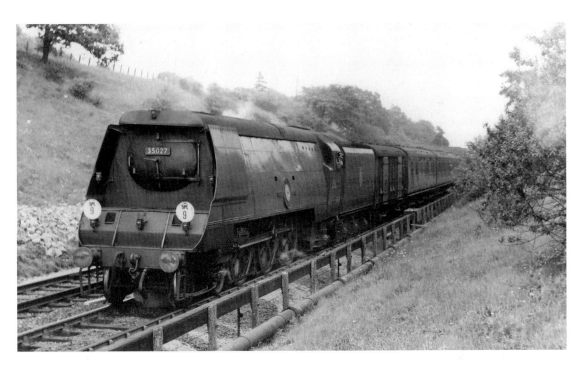

'Merchant Navy' no. 35027 *Port Line* at speed near Hildenborough in May 1953.

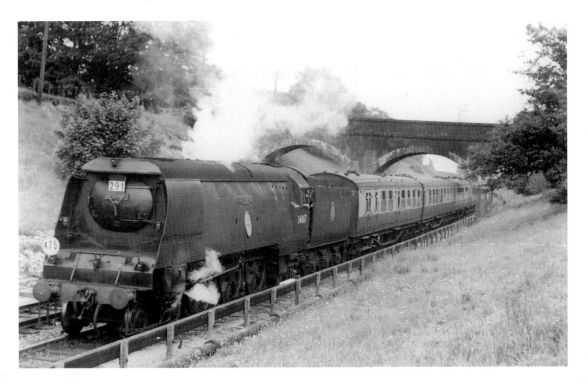

Named after a famous wartime fighter station, 'Battle of Britain' no. 34067 *Tangmere* is also photographed near Hildenborough in May 1953.

Tonbridge, where most trains stop, is the meeting point of the Edenbridge–Margate line, and the Sevenoaks–St Leonards Line. The summer sees a great many specials.

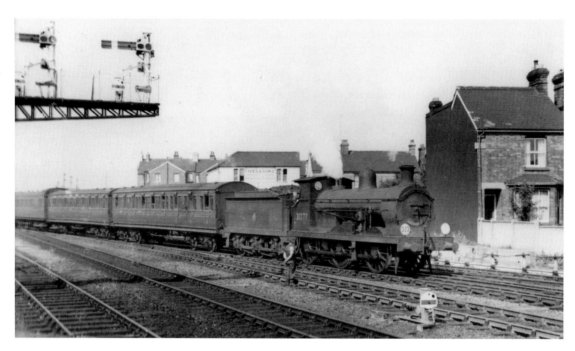

Class C 0–6–0 no. 31277 was photographed arriving in Tonbridge, with a train from Reading.

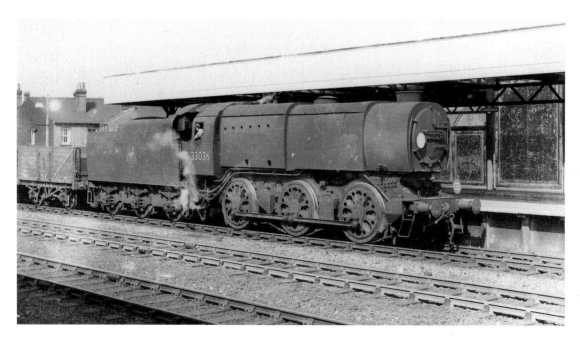

Ql 0–6–0 no. 33036 at the head of a coal train makes its way through Tonbridge station.

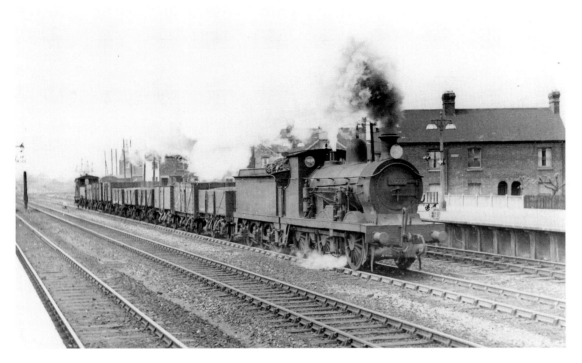

Another coal train working its way through Tonbridge, with Class C 0–6–0 no. 31717 providing the power.

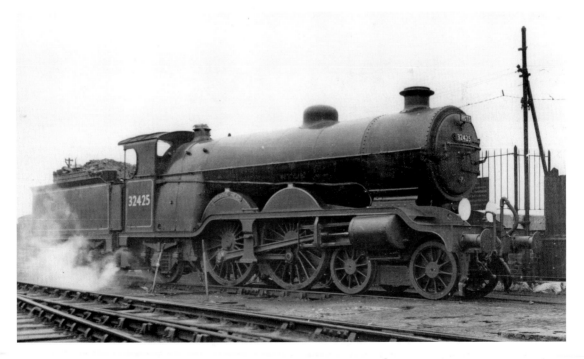

In the shed yard at Tonbridge is H2 Class 4–4–2 no. 32425 *Trevose Head*, a long way from the Cornish headland it is named after.

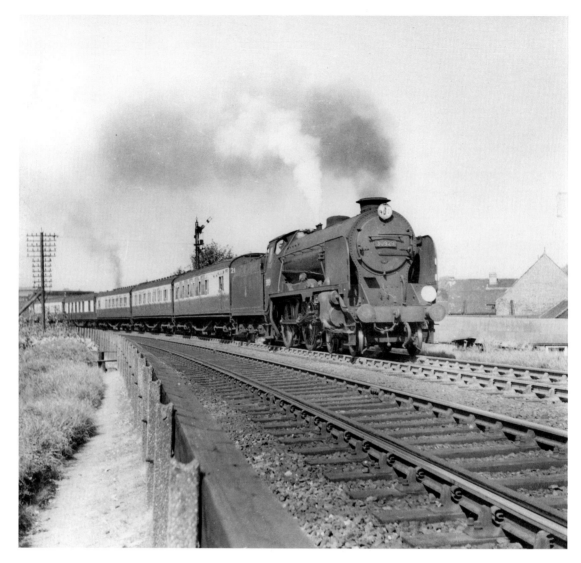

Leaving Tonbridge with a train bound for Hastings is 'Schools' 4–4–0 no. 30929 *Malvern*.

On the Tonbridge–Margate line just after Paddock Wood there are two junctions, one going north to Maidstone, while heading south is the branch to Hawkhurst.

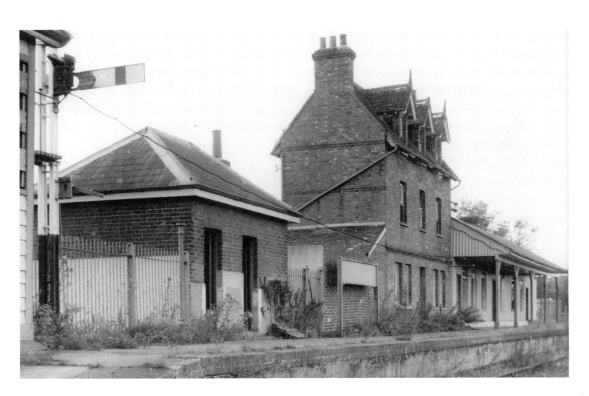

Goudhurst station on the Hawkhurst branch closed in 1961 under the Beeching axe.

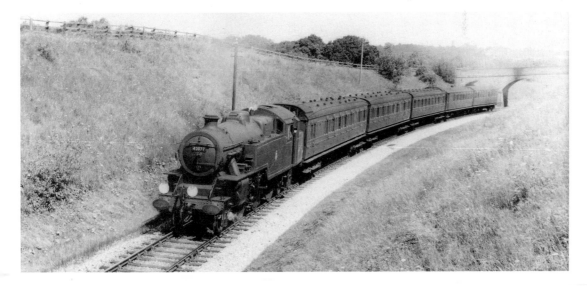

A few Midland region engines of the 2–6–4T design worked on the Southern. Here 4MT no. 42077 is seen approaching the end of the Hawkhurst branch in 1955.

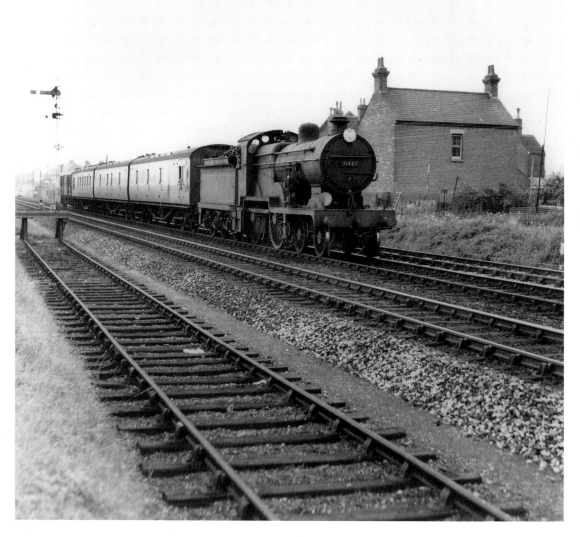

Dl Class no. 31487, a 4–4–0 from 1901 – another Wainwright design for the SECR – photographed near Paddock Wood in 1956.

Heading south again from Tonbridge, the train passes through several small stations before arriving at Tunbridge Wells West, opened for traffic in 1845 as a terminus for the South Eastern Railway. It remained a terminus until 1851, when the line opened to Robertsbridge.

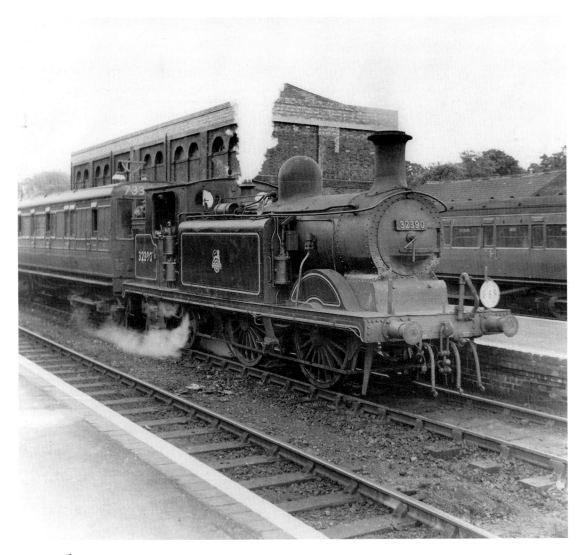

D1 4-4-0T no. 32390 photographed at Tunbridge Wells with a train to East Grinstead. This was another Wainwright design for the SECR. *No.' Designed by Marsh for LBSCR*

D3 0.44.T

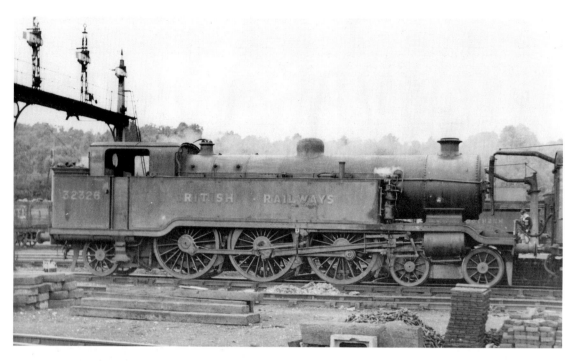

J Class 4–6–2T no. 32326, a Marsh design for the LB&SCR, is photographed at Tunbridge Wells shortly after the railways were nationalised in 1948.

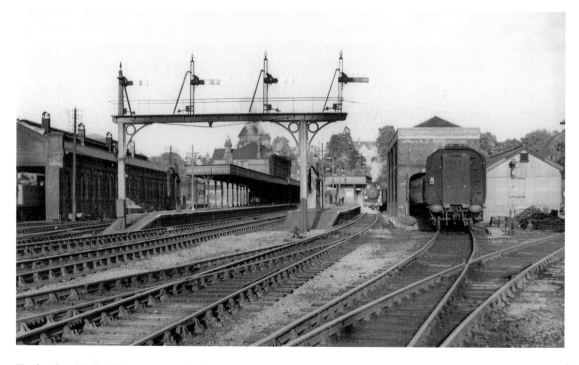

Tunbridge Wells West station, which served passengers who wanted to go to Eastbourne or Brighton, was opened in 1866 for the LB&SCR.

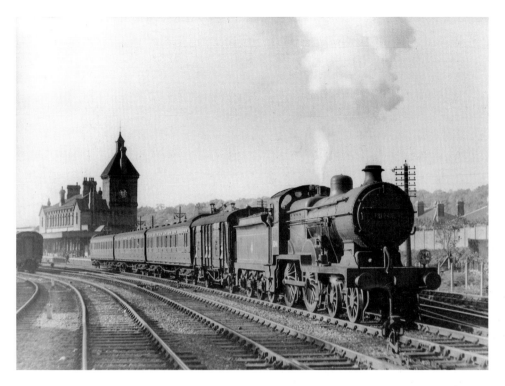

Dl Class 4–4–0 no. 31246 heads an Eastbourne-bound train away from Tunbridge Wells West in 1955.

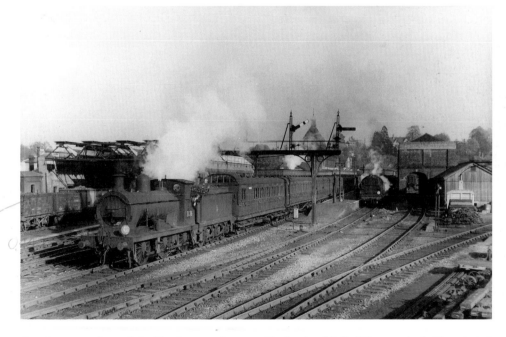

Another train bound for Eastbourne leaving Tunbridge Wells West, with C Class 0–6–0 no. 31716 in charge.

Almost as soon as the train leaves Tunbridge Wells West station, the line forks left to continue south to St Leonards, while the right fork goes into a short tunnel before continuing to Groombridge.

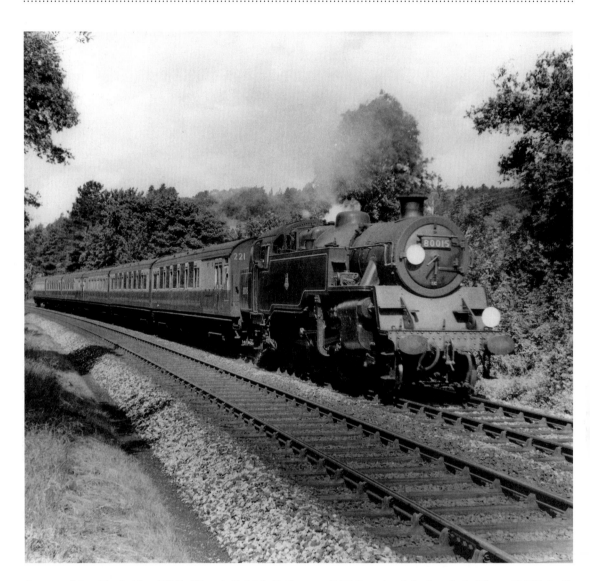

Approaching Tunbridge Wells West is British Railways 4MT Standard design 2–6–4T no. 80015, built at Brighton in 1951.

Class 13 4–4–2Ts were introduced in 1907 to a Marsh design for the LB&SCR. Here, no. 32023 is seen at Groombridge.

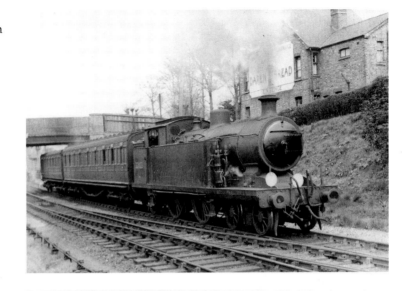

Ul Class 2–6–0 no. 31906, works its way through Ashurst Junction with a train to Tunbridge Wells West.

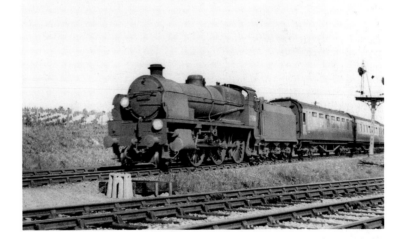

Eridge station is the next stop to Groombridge on the Tunbridge Wells West line to Eastbourne.

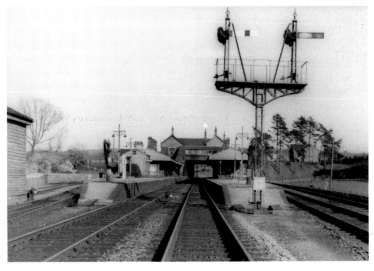

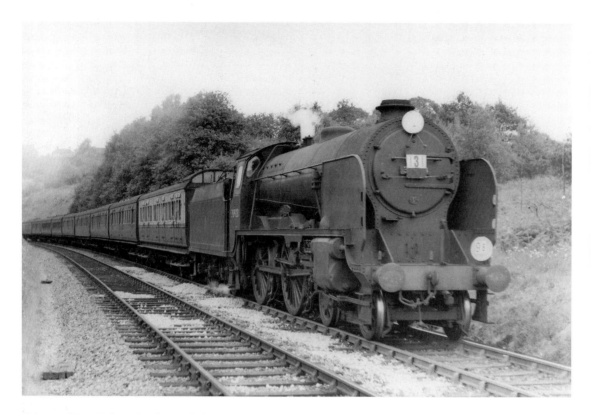

Approaching Robertsbridge is 'Schools' 4–4–0 no. 30928 *Stowe* on its way to St Leonards and Hastings, with a train from London Bridge. Stowe, the public school, was founded in 1923 with less than 100 pupils, but one of these pupils was to become a hero: Group Captain Leonard Cheshire received the Victoria Cross for his war work with the Pathfinder Force. He also founded the Cheshire Homes.

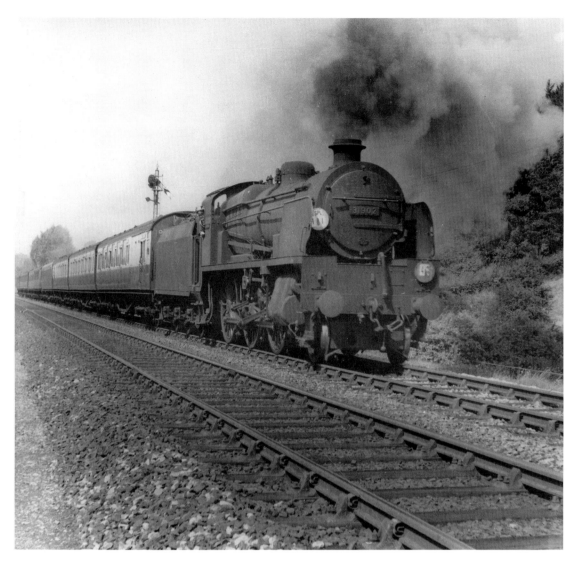

U1 Class 2–6–0 no. 31902 near Robertsbridge with a London Bridge–Hastings train. At Robertsbridge there is a junction that heads north to Headcorn, built by the Kent & East Sussex Light Railway.

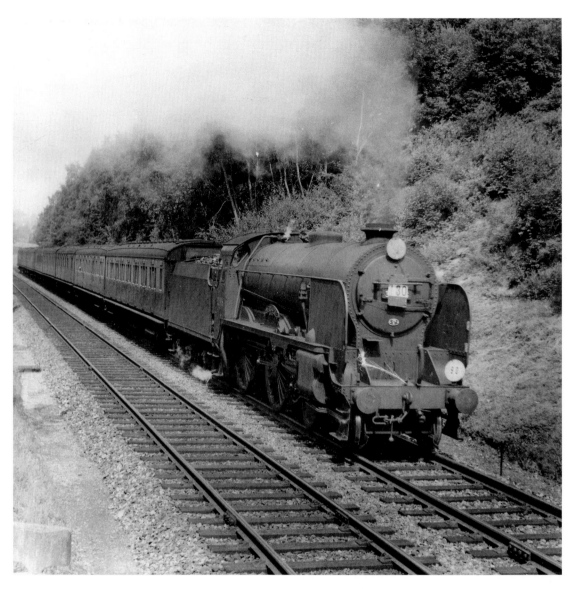

'Schools' no. 30906 *Sherborne* near Battle, not far from St Leonards. Hastings was its destination, having departed from London Bridge station. Sherborne had a pupil whose name was unknown during the Second World War – Alan Turing – who was one of the brilliant and top-secret mathematicians who worked on the Enigma project that helped to win the war.

Getting near to St Leonards are three photographs at Crowhurst, just 3 miles from
Warrior Square – St Leonards' main station.

R Class 0–4–4T no. 31671 near
Crowhurst with a passenger
train to St Leonards.

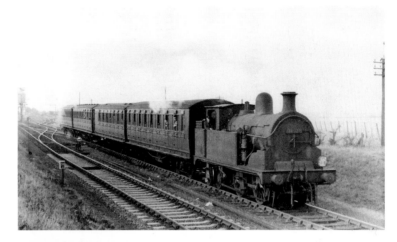

Also near Crowhurst is
Class C2X 0–6–0 no. 32434,
introduced in 1908, with a
mixed freight.

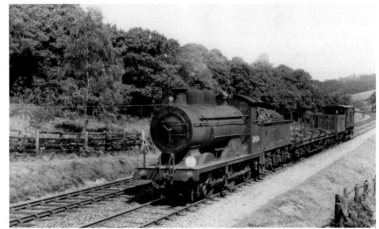

Class E4 0–6–2T no. 32581 also
photographed at Crowhurst
with what looks like a parcels
train.

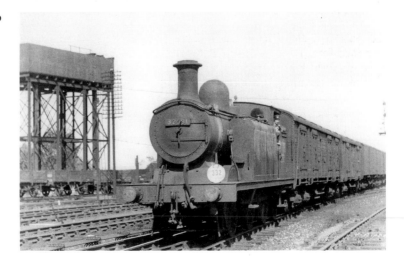

The final destination for railway enthusiasts is St Leonards shed 74E. Our fellow enthusiast, who knows more about the Southern region than me, has done a fine job talking us through to St Leonards from London. Now we will be back to London where we will board a train at Victoria for the final part of our journey.

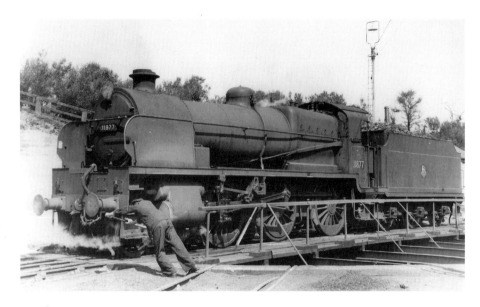

A big effort from the fireman to turn NI 2–6–0 no. 31877 on the St Leonards turntable.

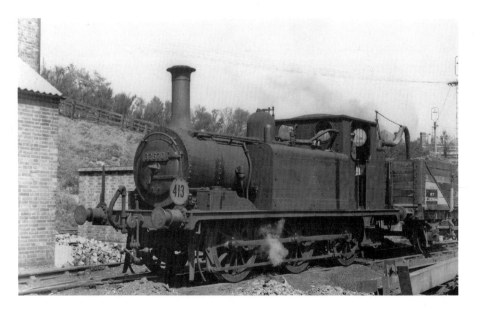

AIX Class 0–6–0T no. 32670, designed by Stroudley in 1872. This was one of the longest-serving steam engines at work on British Railways, and though rebuilt several times it still retained many original parts. This photograph was also taken in the yard at St Leonards 74E shed in 1953.

Victoria station was, in the early days, a bit of a mish-mash. One part was built on the east side for the Victoria Station and Pimlico Railway, and was used by the London, Chatham & Dover Railway, while the west side was built for the London, Brighton & South Coast Railway. Opened to traffic in the 1860s, a solid wall separated the two stations which lasted in this state until the grouping in 1923. The Southern Railway took the decision to make it one station and removed the dividing wall. When the stations were built, the local upper-crust residents objected to the tracks being at high level, with the result that the start from Victoria was quite steep, a 1 in 64 gradient continuously until it crossed the Thames. This will be the last leg of our Southern journey, which will end in Brighton.

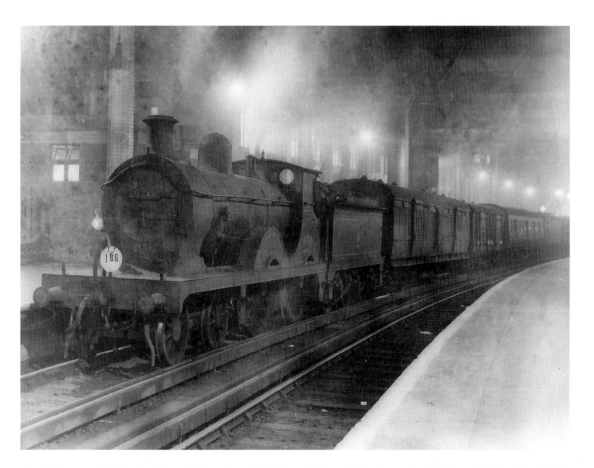

A night view at Victoria, Class D 4–4–0 no. 31746, a 1901 build designed by Wainwright for the SECR, with a Brighton train in 1952 looks a bit like a foggy night in London town, with smoke and steam drifting around.

With the assistance of an M7 tank loco we have left Victoria behind, and are on our way to Brighton. After we cross the Thames, we will be going through Clapham Junction. Once through the station, we branch left to Wandsworth and take the London, Brighton & South Coast Railway through Balham and Streatham.

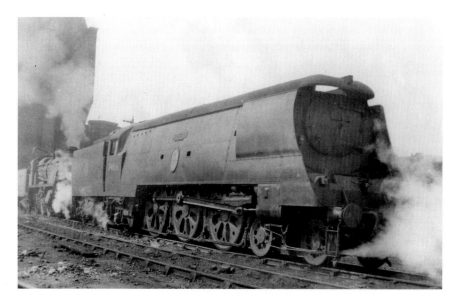

'Battle of Britain' no. 34066 *Spitfire*, named after one of the most famous fighter planes to take to the skies. The Spitfire aircraft was designed by R.J. Mitchell, Chief Designer at Supermarine. The train is seen being coaled at Stewarts Lane, in preparation for backing down to Victoria.

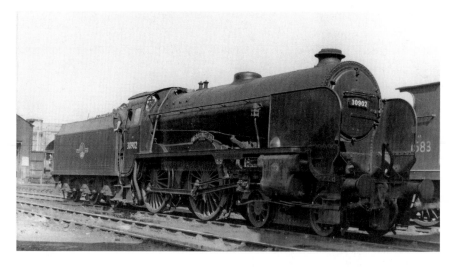

'Schools' 4–4–0 no. 30902 *Wellington* photographed at Stewarts Lane. The school was opened in the mid-nineteenth century in Berkshire and Queen Victoria was a moving force in its establishment as it was intended to provide schooling for the sons of fallen officers who had served in her armies around the world.

Stewarts Lane shed 73A, one of the Southern's major Locomotive Servicing Depots, was responsible for the servicing of all the locomotives that arrived and departed from Victoria.

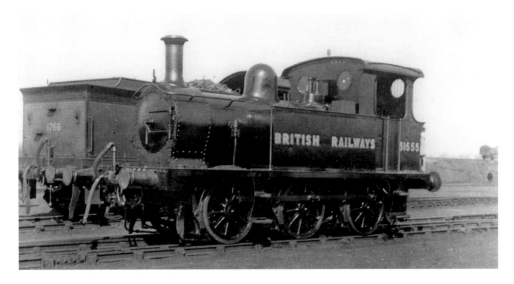

P Class 0–6–0T no. 31555, a 1909 design by Wainwright for the SECR. It was introduced to work push and pull trains on branch lines in the Kent area, used latterly for shunting and station pilot duties. This view is at Stewarts Lane in 1953.

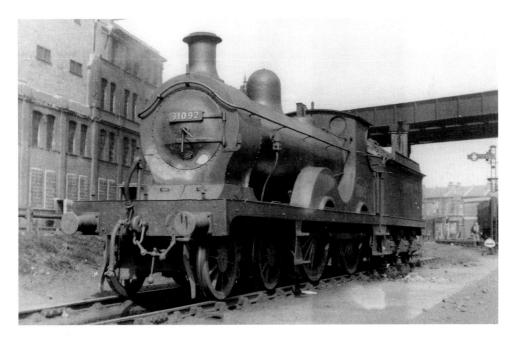

4–4–0 D Class no. 31092. The Southern Railway certainly believed in keeping their locos at work for as long as possible. This view of no. 31092 was taken in the yard at Stewarts Lane in 1951 after completing 50 years of service.

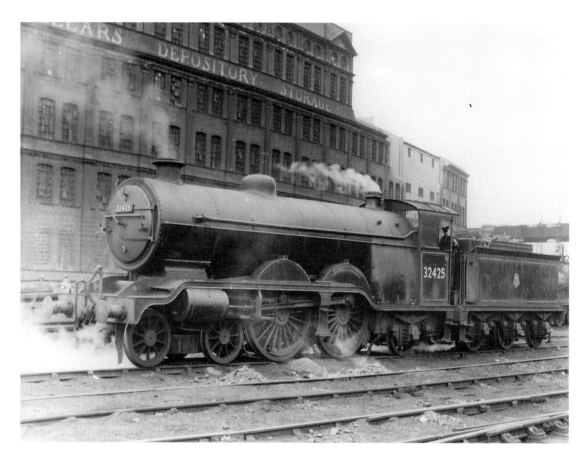

No. 32425 *Trevose Head*, an H2 Class 4–4–2, was a 1911 Marsh design for the London, Brighton & South Coast Railway. With a full tender, it will soon be running back to Victoria from Stewarts Lane, perhaps to head a Brighton train.

No. 30756 *A.S. Harris*, introduced in 1907. It was designed and built for the Plymouth, Devonport & South Western Junction Railway, specifically for shunting in Plymouth docks. It was an 0–6–0T with small wheels of 3ft 10in to enable it to work the tight curves in the docks area, seen here in the yard at Stewarts Lane in April 1951.

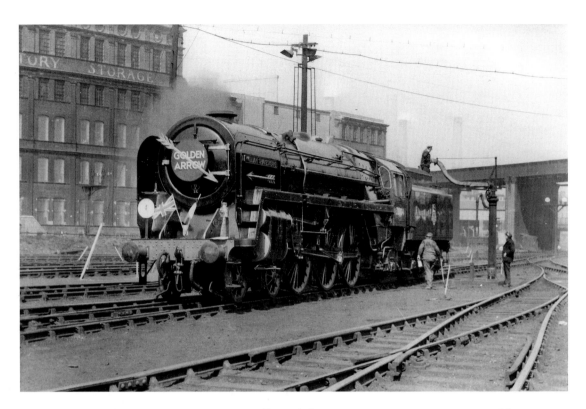

Looking immaculate, Britannia no. 70004 *William Shakespeare* is seen receiving water and last-minute checks before leaving Stewarts Lane. It was about to back down to Victoria to work the Southern region train of the day, the 'Golden Arrow' Victoria–Dover–Paris service.

Clapham Junction is now approaching. We shall go through the left-hand side of the station and through Balham and Streatham. As always when going through Clapham, everyone is looking out for steam, but there are so many electric trains on the move, that we did not see much.

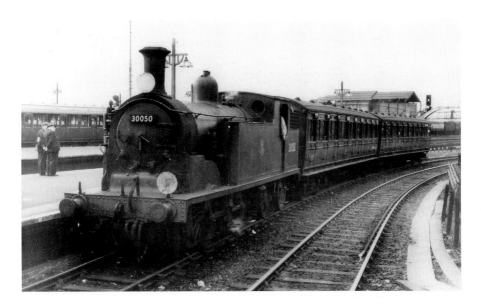

M7 0–4–4T no. 30050 heads a Croydon-bound train through Clapham Junction in the early 1950s.

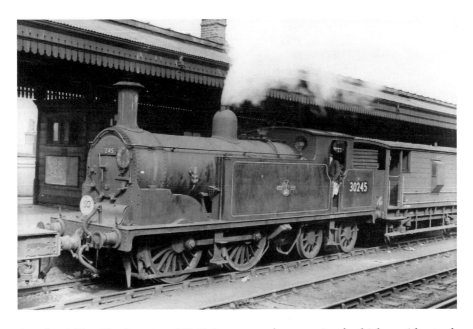

Another M7 at Clapham, no. 30245. It seems to have a mix of vehicles, with a tank behind the loco; could it be a weed-killing train?

Past Streatham Common our train is picking up speed. At Streatham there is a big junction, with lines leading back to Wimbledon and to Mitcham. Freight trains to Norwood also pass through this junction. Soon we shall be passing through Selhurst and approaching South Croydon, after which we will be leaving the suburbs of London behind.

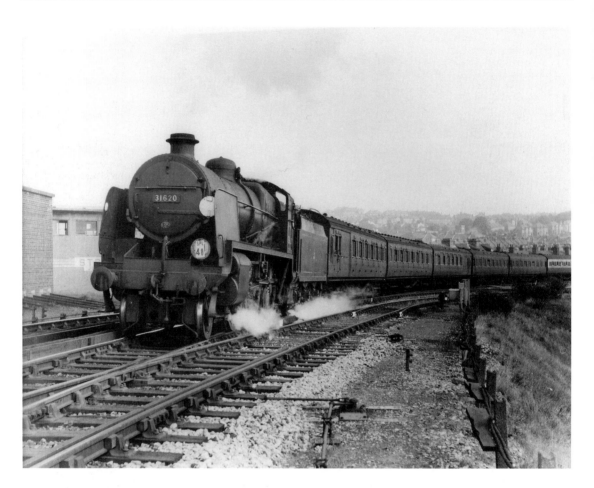

U Class 2–6–0 no. 31620 near Selhurst on its way to Brighton.

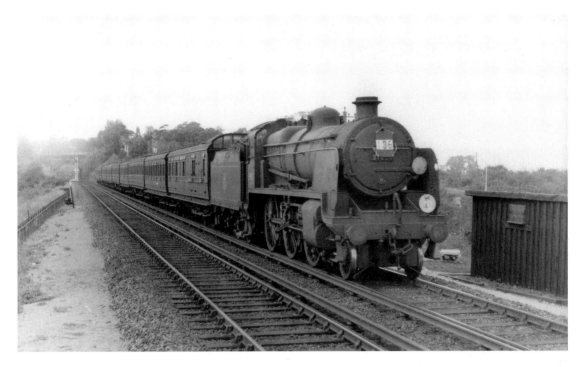

This photograph of U Class 2–6–0 no. 31621 was taken near Mitcham with a train to Portsmouth. It had started its journey at Victoria.

East Croydon station opened for the LB&SCR simply as 'Croydon' in 1841. It received the East Croydon moniker in 1850.

At Croydon, the line to St Leonards and Eastbourne leaves us, going south through Selsdon and Upper Warlingham.

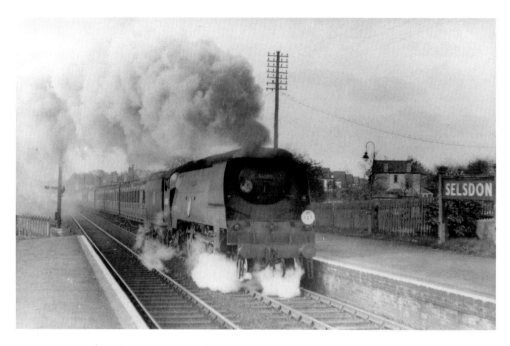

'Battle of Britain' no. 34089 *602 Squadron* speeds through Selsdon on its way to Eastbourne.

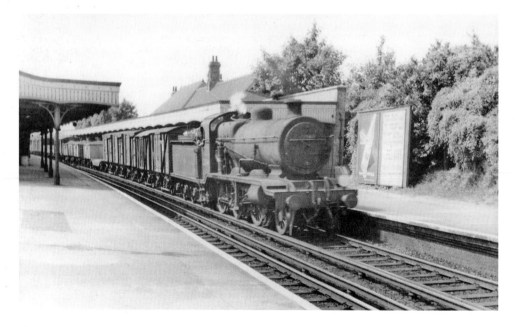

K Class 2–6–0 no. 32344, a Billington design in 1913 for the LB&SCR, seen at Purley in the early 1950s.

Three views at Upper Warlingham of three different locos providing the power, all on their way to Tunbridge Wells and all photographed on the same summer's day in 1950.

E Class 4–4–0 no. 31036, originally a SECR engine. Another Wainwright design of 1909, it is seen speeding its way to the south coast.

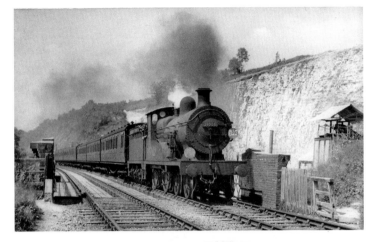

Hl Class 4–4–2 no. 32037 *Selsey Bill*, an Atlantic design by Marsh for the LB&SCR in 1905.

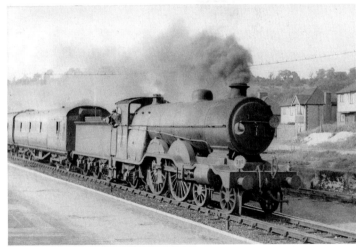

L Class 4–4–0 no. 31761, a SECR of 1914.

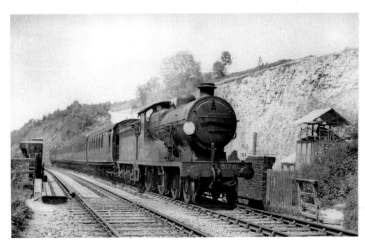

Travelling fast now, we are through Coulsdon, some 15 miles from Victoria. It's time for a drink and a bite to eat , but it won't be long before we slow and come to a halt at Redhill, another big junction; the South Eastern & Chatham line from Dorking in the west, crosses our route on its way to Tonbridge.

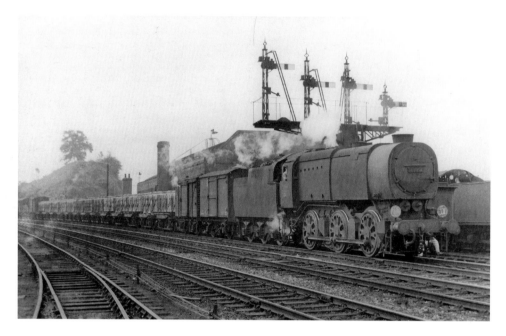

Ql no. 33001 making its way through Redhill, with a long mixed freight.

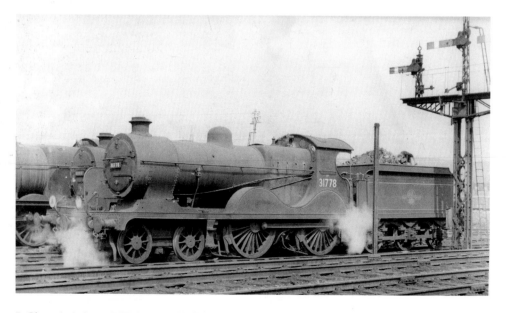

L Class 4–4–0 no. 31778 on Redhill shed 75B in 1959. It looks as if it has a Western region loco as companion.

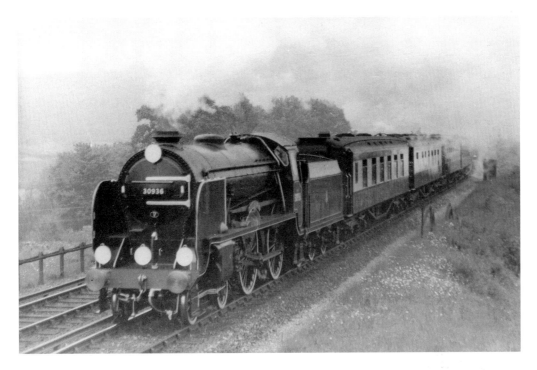

'Schools' 4–4–0 no. 30936 *Cranleigh* near Redhill with a train that has come from the Midland region via Willesden in 1953. The cricket writer and broadcaster Jim (E.W.) Swanton was one of Cranleigh's pupils, and no doubt played many cricket matches there.

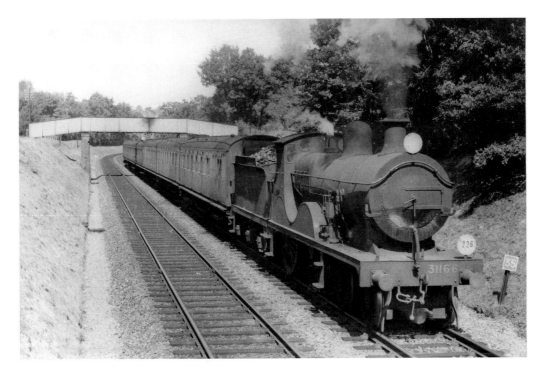

E Class 4–4–0 no. 31166 making its way through Redhill with a train to the south coast in 1956.

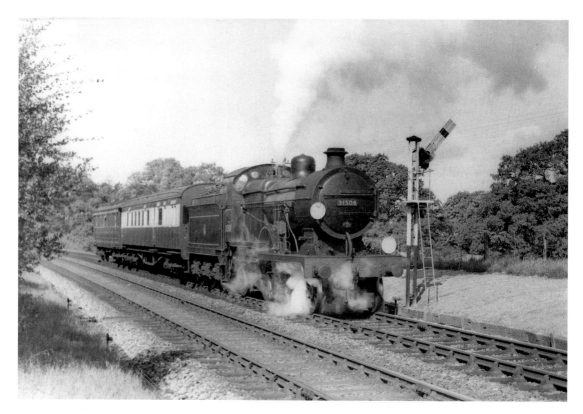

El 4–4–0 no. 31506 makes a fine picture near Dorking.

U Class 2–6–0 no. 31791 approaching Betchworth near Redhill in 1959.

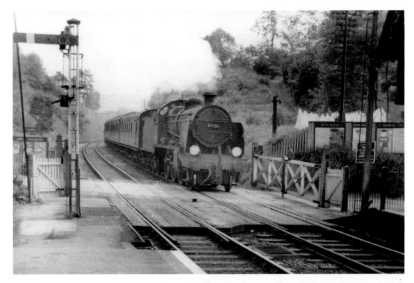

Q Class 0–6–0 no. 30545 photographed at Ifield near Three Bridges in 1956.

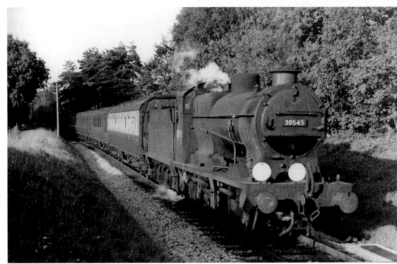

'King Arthur' 4–6–0 no. 30764 *Sir Gawain* near Three Bridges.

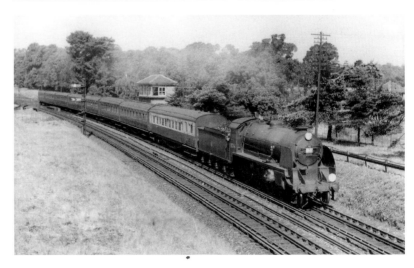

Two pages of expresses near Three Bridges making their way to the south coast holiday resorts.

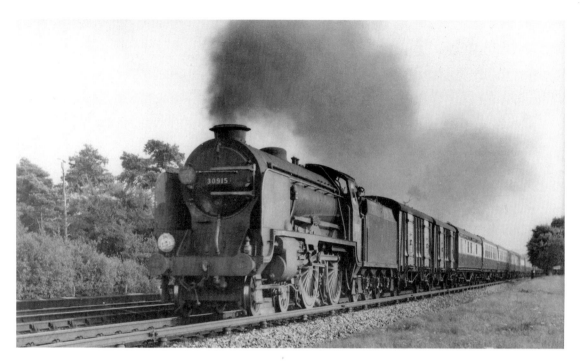

'Schools' no. 30915 *Brighton* working hard on its way south in 1955.

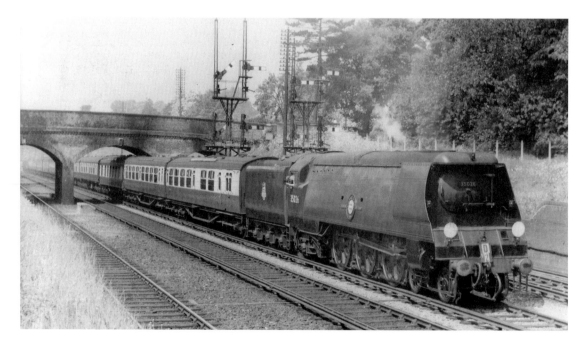

'Merchant Navy' no. 35026 *Lamport & Holt Line* heading south in sunny weather.

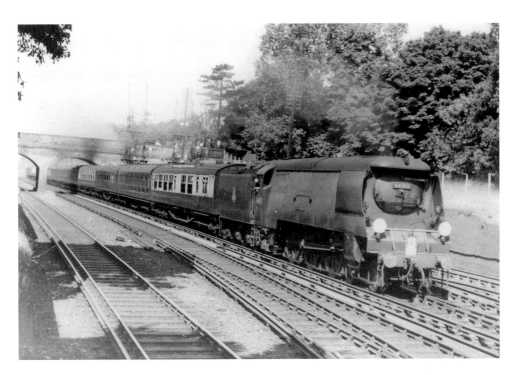

'West Country' 4–6–2 no. 34103 *Calstock* working its way south through Three Bridges.

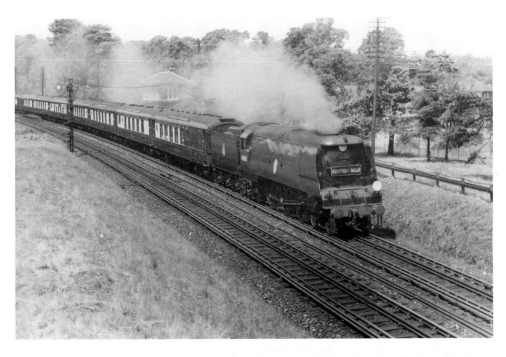

Photographed near Three Bridges is the 'Kentish Belle' headed by 'Battle of Britain' no. 34067 *Tangmere*. This notable express makes its way through Kent to the south coast.

At Three Bridges our train is travelling in excess of 60mph, so apart from admiring the view that is flashing past the windows, we take the opportunity to look at a railway map and listen to our Southern expert tell us about the area we are passing through. He tells us that the line from Christs Hospital will cross us on its way to East Grinstead, where the line goes north to Hurst Green and Oxted, and south through Horsted Keynes.

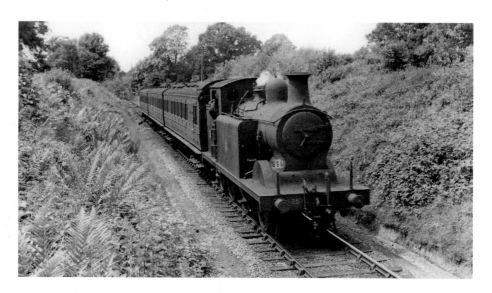

E5 Class 0–6–2T no. 32571, another of Billington's successful designs for the LB&SCR, first emerged from Brighton Works in 1902. It is photographed near East Grinstead.

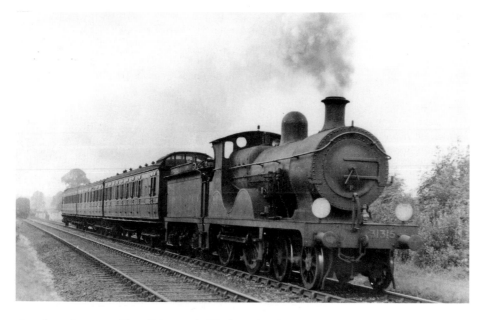

Another view near East Grinstead. Working hard with a three-coach train is E Class no. 31315, a 4–4–0 of 1905 vintage.

Hurst Green Junction near Oxted is the setting for this view of 'Schools' no. 30919 *Harrow* in 1948. This school can probably claim that one of their old boys is one of the most famous men the world has ever known: Winston Churchill, Britain's Prime Minister during the Second World War.

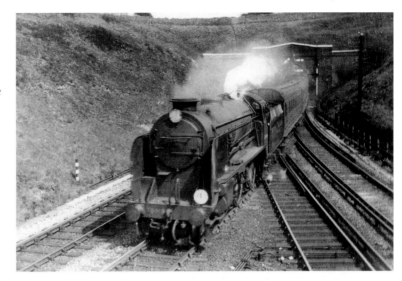

An LCGB special, 'The Southern Counties Limited' headed by H2 no. 32424 *Beachy Head*, is seen taking on water at Oxted.

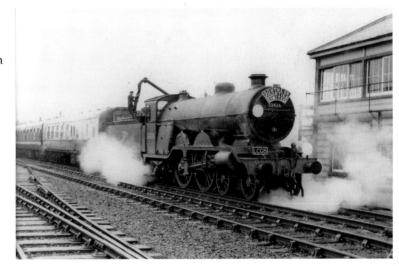

H Class 0–4–4T no. 31530 at Westerham, terminus of the branch from Dunton Green on the main line to St Leonards near Sevenoaks.

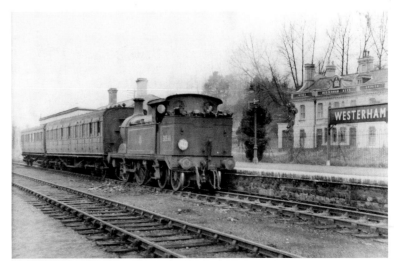

Having left Three Bridges behind, we are through Balcombe and Haywards Heath, now approaching Hassocks. It is a lovely day with bright sunshine, but we are about to be plunged into darkness as coming up is Clayton Tunnel, about 1½ miles long, with lovely castellated portals. The unusual part of this tunnel is the little cottage that sits between the towers directly over the tracks; presumably it was built when the tunnel was completed in the 1840s. The living conditions must have been a bit primitive and constantly full of smoke, as we have all seen how the smoke curls out of the tunnel after the passage of a steam engine.

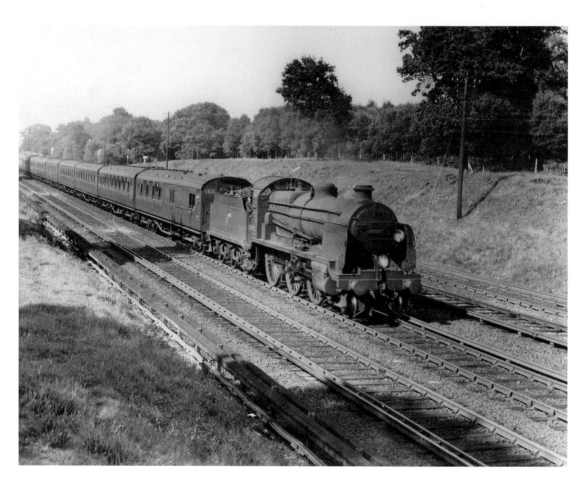

Getting near Brighton in bright sunshine is this view of U Class no. 31800. No doubt there will be many passengers starting their holidays, so they get the kids back to their seats, check the luggage and prepare to leave the train at Brighton, ready to make their way to a boarding house, hotel or holiday camp.

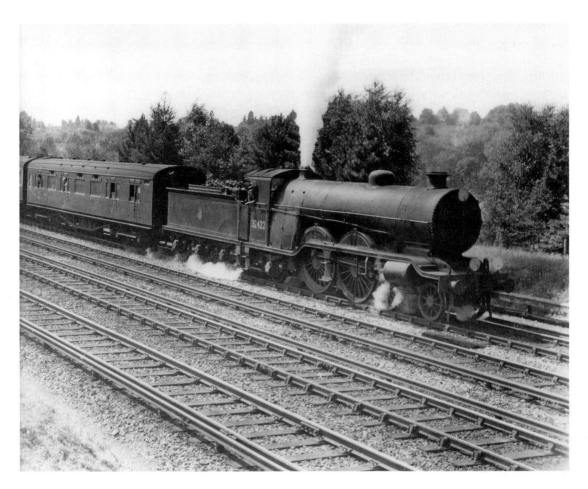

Near the same point, in this view H2 4–4–2 no. 32422 *North Foreland* approaches Brighton with more holidaymakers.

In our compartment we have gathered up all our log books, cameras and bags, and we will leave our compartment as we found it, clean and tidy. Now it's into the corridor to take notes of any steam locos we see. We are slowing down with brakes on, and we come to a halt in Brighton, the end of our Southern journey. Once again I hope it has brought back happy memories as it has for me, because all my journey books are based loosely on my own journeys over the British Railways system.

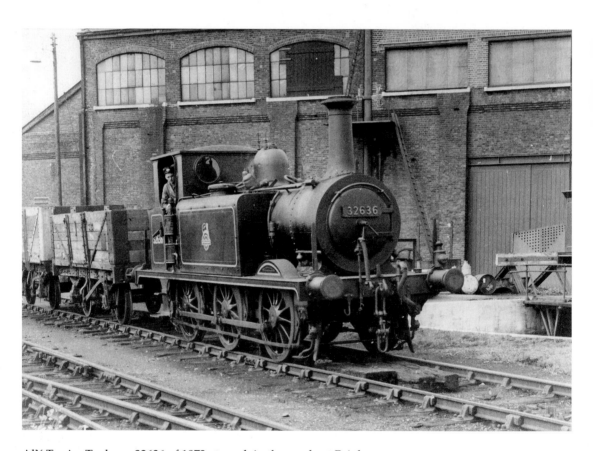

AlX Terrier Tank no. 32636 of 1872 at work in the yards at Brighton.

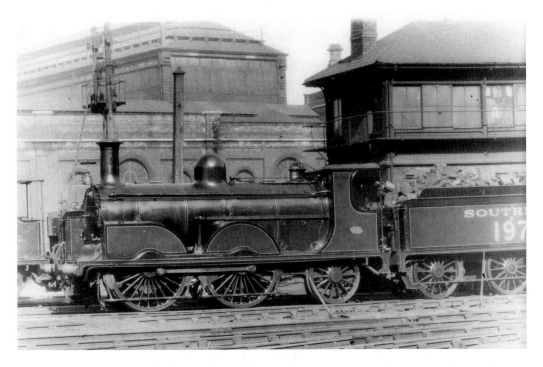

'Gladstone' 0–4–2 no. 197 waiting in the yard at Brighton station. The end of the platform at Brighton afforded a superb vantage point for collecting numbers and taking photographs.

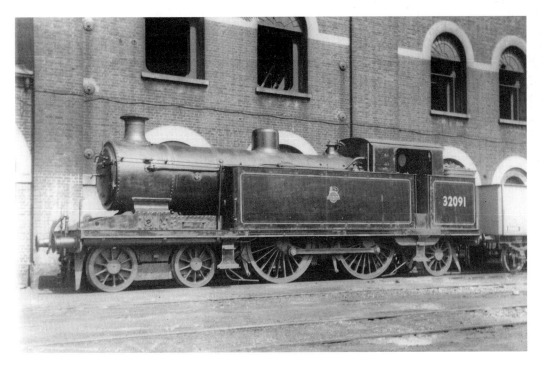

Class 13 4–4–2T no. 32091, a Marsh design for the LB&SCR, in the works yard at Brighton.

Walking down the platform at Brighton's terminus, our group is chatting non-stop about our Southern adventure, and it is with some sadness that we say our goodbyes to make our separate ways home – myself back to Bristol and the Brunswick green locos of the Western region. Thank you for keeping me company on my Southern journey.

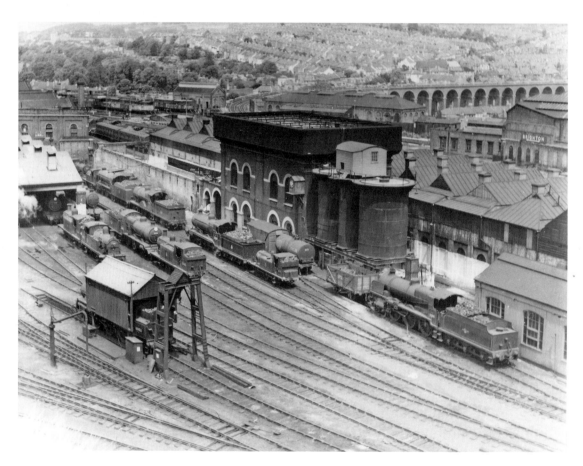

End of the line, a high-level view of Brighton shed 75A and works in 1950.